American Watercolors at the Pennsylvania Academy of the Fine Arts

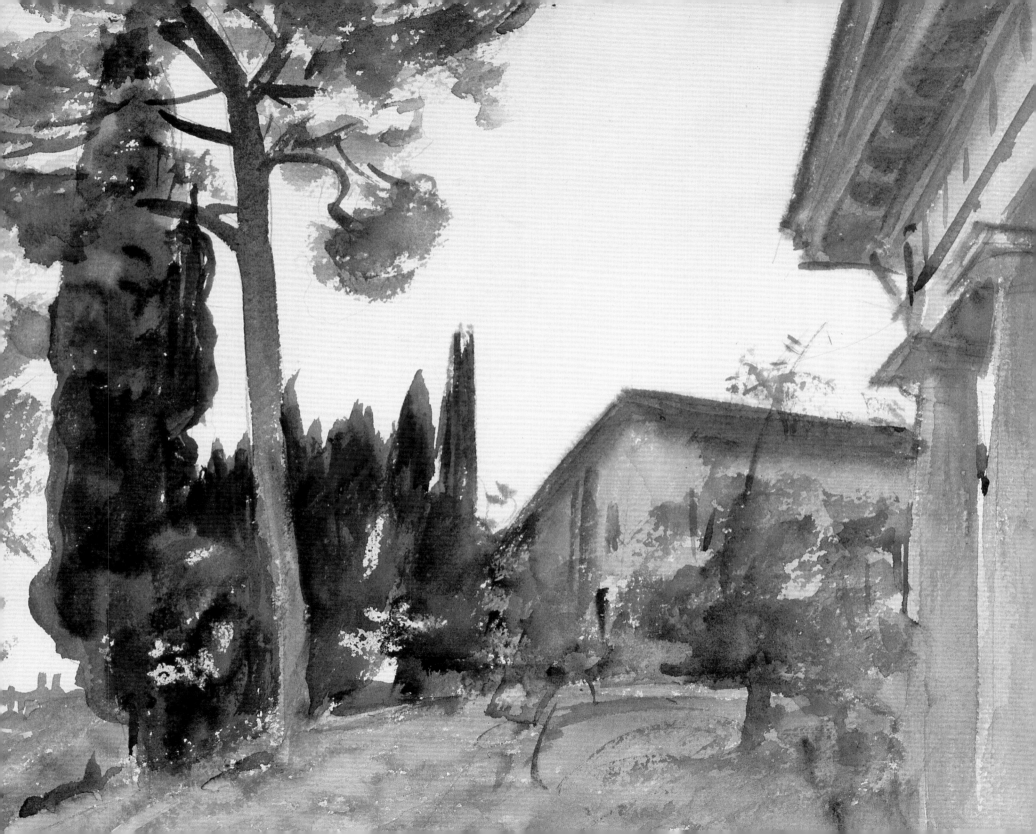

American Watercolors

at the Pennsylvania Academy of the Fine Arts

Jonathan P. Binstock

Kathleen A. Foster

Pennsylvania Academy of the Fine Arts

Published on the occasion of the exhibition
*American Watercolors at the Pennsylvania Academy
of the Fine Arts*
October 14, 2000-January 7, 2001

Curator: Jonathan P. Binstock
Editor: Janet Wilson
Design: Phillip Unetic, Willow Grove, Pa.
Printing: 3r1 Group, Willow Grove, Pa.

©2000 Pennsylvania Academy of the Fine Arts
118 North Broad Street
Philadelphia, Pa. 19102

Printed in the United States.

COVER: Winslow Homer, *North Road, Bermuda*, 1900.
Watercolor and pencil on white wove paper, 13 15/16 x 21"
(35.40 x 53.34 cm). Pennsylvania Academy of the Fine Arts.
Partial Gift and Bequest of Bernice McIlhenny Wintersteen,
1978.19

FRONTISPIECE: John Singer Sargent, *Corfu*, 1909.
Watercolor over graphite on rough wove paper,
13¾ x 19½" (34.93 x 49.53 cm). Collection of Drs. Meyer
P. and Vivian O. Potamkin

Library of Congress Cataloging-in-Publication Data

Pennsylvania Academy of the Fine Arts.
 American Watercolors at the Pennsylvania Academy /
 Jonathan P. Binstock, Kathleen A. Foster.
 p. cm.
 "Published on the occasion of the exhibition American
 Watercolors at the Pennsylvania Academy October 14,
 2000-January 7, 2001."
 Includes bibliographical references.
 ISBN 0-943836-21-2
 1. Watercolor painting, American—Exhibitions.
 2. Watercolor painting—19th century—United States—
 Exhibitions. 3. Watercolor painting—20th century—
 United States—Exhibitions. 4. Watercolor painting—
 Pennsylvania—Philadelphia—Exhibitions. 5. Pennsylvania
 Academy of the Fine Arts—Exhibitions.
 I. Binstock, Jonathan P., 1966-
 II. Foster, Kathleen A. III. Title.
 ND1835.P42 P487 2000
 759.13'074'74811—dc21

 00-011074

Contents

Foreword

Watercolor painting is among the world's most compelling media, yet within the Western tradition, it remained subordinate to oil painting for centuries. The reason is not particularly complex. One of the crucial social facts about watercolor painting is that it has generally been executed on paper (and to a far lesser extent on ivory). The structural weakness of paper, the size in which sheets are made, and the fugitive nature of watercolor pigment itself have made the medium less desirable for great public work. European oil paintings, however, were created principally for public display—for propaganda, inspiration, beautification, and the visual manifestation of power and status. This was an art profoundly linked to architecture, shown within often-elaborate frames that echoed the moldings of the surrounding building.

In contrast with oils, at least until the later eighteenth century, watercolors had a lesser status—that of the sketch or preparatory endeavor. Watercolors were associated with miniature painting, botanical and topographical illustration, and it was only after the English artist J. M. W. Turner's sublime landscapes had been accepted by collectors, critics, and his fellow Royal Academicians that the medium acquired anything like an equivalent cultural value to oil painting.

In addition to the basic problem of status, watercolor was also handicapped by its association with landscape, which, from its origins as an independent genre in the late fifteenth century until the nineteenth century, was seen as a lesser form of art or merely as background to a more elevated subject from history. Indeed, the art historian Christopher Brown has proposed that Peter Paul Rubens painted his remarkable oil landscapes on inexpensive wood panels, composed of several pieces, precisely because these scenes of nature were done only for himself or as gifts for relatives and friends.

We can contrast the relatively low status of the medium in Europe with that of Chinese literati painting, also executed in ink and watercolor on paper. The portability, privacy, and lack of complex technical apparatus required to produce such paintings were among the factors that made the medium of paper so appealing to the intelligentsia, who prided themselves on their amateur status. This was a mirror image of the situation in Europe.

During the past two hundred years, watercolors have gained a much improved status in both Europe and America, and it is with the latter that *American Watercolors at the Pennsylvania Academy of the Fine Arts* concerns itself. Despite all the gains, the underlying factors that have led to the elevation of oil painting over watercolors still prevail on both continents: the potent combination of scale, the capacity to command an architectural space, and the physical strength of oil continue to contribute to the subordination of works on paper. It is hoped that this show will further dispel these prejudices.

Mounted to celebrate the centenary of the Philadelphia Water Color Club, the exhibition contains a representative range of work produced in America over the past two centuries. It will surely be clear to all viewers that the artists featured constitute an extremely distinguished gathering, whose exceptional contributions to the medium merit wider appreciation on an international level.

American Watercolors at the Pennsylvania Academy of the Fine Arts showcases the Academy's fine collection together with outstanding work on loan from collectors within the region, whose generosity we truly appreciate. Although the special contributions of many individuals have made this show possible, five in particular deserve to be singled out. Donald R. Caldwell, Chair of the Pennsylvania Academy of the Fine Arts Board of Trustees, suggested that we revisit this important part of the Academy's collection and celebrate the activities of the Philadelphia Water Color Club. Vivian Potamkin, Vice-Chair of the Board, and her husband, Meyer (Pat) Potamkin, have supported the idea enthusiastically and generously lent a considerable number of works to the show from their distinguished collection.

The noted watercolor expert Kathleen Foster has contributed to this catalogue a fine history of the medium as it developed out of, and then independently of, European tradition, right up to the present day, while Jonathan Binstock has summarized the role of the Pennsylvania Academy in both the promotion and collection of watercolors. It is our hope that visitors to this special exhibition will find in the subtlety and intimacy of the medium not only a different resonance from painting in oil but also a vitality that more than repays their attention.

Derek Gillman
Edna S. Tuttleman Director and Provost

Lenders to the Exhibition

CIGNA Museum and Art Collection

Sam Gilliam

Jules and Connie Kay

Makler Family Collection

Dr. and Mrs. Perry Ottenberg

Philadelphia Museum of Art

Drs. Meyer P. and Vivian O. Potamkin

Private Collections

The Harold A. & Ann R. Sorgenti Collection of Contemporary African American Art

Acknowledgments

An art museum's permanent collection, as monolithic and self-evident as it may seem, is more accurately understood as the sum of multifarious ideas, decisions, and efforts. Like art history itself, a significant collection is always growing and, as a result, is difficult to grasp in its entirety. With each individual contribution—whether a collector's gift, a curator's historical insight, a paper conservator's technical expertise, or a framer's talent for crafting the ideal finish—a collection changes, creating new potential for scholarly and aesthetic interpretation.

Spanning nearly two centuries, as no other American art institution does, the Pennsylvania Academy of the Fine Arts has benefited from and been a repository for innumerable individual acts of intelligent professionalism, dedication, and generosity. Directors, curators, collectors, registrars, conservators, preparators, art dealers, and artists' descendants, among others, have cooperated in the complex task of building and maintaining a collection that will ultimately outlast them all.

It is inevitable that the whole of a collection such as the Academy's amounts to an importance much greater than the sum of the individual contributions of which it consists. It is precisely for this reason that *American Watercolors at the Pennsylvania Academy of the Fine Arts* presents an ideal opportunity to consider as well as thank the many people, past and present, who have labored, with love and dedication, to make this historic institution a unique force in the cultural life of the nation today. A list of names detailing nearly two centuries of personal and institutional accomplishment would be long indeed. With a grateful nod to the past, then, I would like to thank those individuals who are working to fulfill some of the dreams of our forebears.

A project of this scope and scale could not have been completed without the help of many people. A number of the exhibited works come from Philadelphia-area private collectors who have lent generously to augment this survey. I am especially indebted to Jules and Connie Kay and to Drs. Meyer P. and Vivian O. Potamkin for their many important contributions. Among the administration and senior staff of the Academy, I would like to express my appreciation to Donald R. Caldwell, Chair of the Board of Trustees; Joshua C. Thompson, President; Daniel Rosenfeld; and Sylvia Yount, Chief Curator, for being advocates of the project long before my arrival at the Academy in February 1999. I am also grateful to Mrs. Jane B. Miluski, former President of the Philadelphia Water Color Club, for encouraging the Academy to take stock of its watercolor collection. Derek Gillman, Edna S. Tuttleman Director and Provost, was a crucial force behind the realization of the catalogue and the exhibition, the installation of which has benefited greatly from his expert advice.

The Academy receives funding for its exhibitions, educational initiatives, and general operating support from a number of sources. For the year 2000, the Barra Foundation, Independence Foundation, and the Pennsylvania Council on the Arts, among others, have all provided the institution with major general operations grants. Some of these funds have been allocated to cover the costs of this exhibition and catalogue, and so it is with much gratitude that I recognize their contributions here.

Among the Academy's staff, I would like to thank Penny Blom, Director of Marketing and Communications; Aella Diamantopoulos, Chief Conservator; Michael Gallagher and Brian Murray, Preparators; Kevin Glass, Director of Finance; Mary Anne Dutt Justice, Director of Development; Barbara Katus, Manager of Rights and Reproductions; Cheryl Leibold, Archivist; Gale Rawson, Chief Registrar; and Ka Kee Yan, Registrar's Assistant. Their assistance was, and continues to be, invaluable to the process. Glenn Tomlinson, Director of Museum Education and Audience Development, and Mark Hain, Museum Education Associate, collaborated on the exhibition's didactic material. Curatorial interns Chloé Kraemer and Maria Velez researched individual artists and works, and Tara Cliff, an intern in the Registrar's office, assisted in the preparation of the exhibition checklist.

At the Conservation Center for Art and Historic Artifacts, Mary Schobert, Jim Moss, Susan Bing, and Kate Jennings ensured the stable condition of the work and the safety of its housing. Kevin Strickland of Kevin Strickland Fine Art Services manufactured many of the beautiful frames for the exhibition display. Janet Wilson edited this handsome volume, which was designed by Phillip Unetic.

Finally, I would like to thank Kathleen Foster, Curator of 19th- and 20th-Century Art at the Indiana University Art Museum and a renowned expert in the field of American watercolors, for her scholarly contribution to this book. Dr. Foster was a curator at the Academy from 1979 through 1990, during which time she oversaw a project to catalogue the Museum's collection of works on paper. *American Watercolors* is, to a certain extent, the culmination of that research, begun decades ago, and yet one more example of how the Academy's past continues to inform its present.

Jonathan P. Binstock
Assistant Curator

Introduction

American Watercolors at the Pennsylvania Academy of the Fine Arts brings together for the first time in the Academy's history the highlights of 125 years of watercolor collecting. Drawn primarily from the Academy's permanent holdings, and also from select Philadelphia-area private collections, this major exhibition of rarely displayed objects features more than 160 works by nearly as many artists, spanning more than two centuries, from the neoclassicism of Benjamin West to the abstraction of Sam Gilliam.

The exhibition's institutional and regional emphasis provides a special opportunity to explore the Academy's key role in the cultivation of watercolor painting in Philadelphia and the United States. Theodore E. Stebbins, Jr., a historian of American art and watercolor specialist, considers the Academy to be among the great historical proponents of the medium in this country, along with the Metropolitan Museum of Art, the Museum of Fine Arts, Boston, and the Corcoran Gallery of Art.[1] Watercolor had been a part, albeit a small one, of the Academy's School programs and its annual exhibitions as early as 1811, after which the first watercolors entered the collection. As Kathleen Foster notes in her essay for this volume, serious interest in the medium began to blossom by 1850, approximately sixteen years before the founding of the American Watercolor Society in New York. The growing demand for watercolor exhibitions in the Philadelphia area led, in 1904, to the establishment of a major annual exhibition at the Academy, the "Philadelphia Water Color Exhibition," which was devoted specifically to this medium and other graphic works.

During the last quarter of the nineteenth century, the Academy began acquiring watercolors in earnest for its permanent collection, mainly through gifts. Long viewed as the province of artists and connoisseurs with specialized tastes,

watercolors began to win respect among a broader public only in the late nineteenth century. In 1886 Frank Mark Etting donated a cache of late eighteenth- and early nineteenth-century watercolor miniatures, which represent some of the earliest examples of watercolor painting in the Academy's holdings. The oldest work now in the collection is a magnificent portrait by Benjamin West, given in 1983 by the celebrated Philadelphia philanthropist Bernice McIlhenny Wintersteen.

Many private collectors, foundations, artists, their heirs and descendants have contributed regularly to a growing treasure trove of watercolors from every period in American art in virtually every style. Many artists are represented by a single work, but a number have been collected in depth, including James Peale, William Trost Richards, Thomas Anshutz, Charles Lewis Fussell, Violet Oakley, Arthur Dove, Charles Demuth, and Robert Motherwell. And the collection continues to grow. Harold A. and Ann R. Sorgenti's recently promised gift of more than fifty works by contemporary African American artists, which will be the largest contribution to the Academy's collection in recent history, includes six watercolors and gouaches by such outstanding artists as Willie Birch, Jacob Lawrence, and Raymond Saunders.

It is especially significant that the Academy has scheduled this exhibition for the year 2000, when the Philadelphia Water Color Club celebrates its centennial. Founded in 1900, the Philadelphia Water Color Club co-sponsored the annual "Philadelphia Water Color Exhibition" at the Academy from its inception in 1904 until 1969, when the Academy ceased all of its annual exhibitions. These juried showcases, from which the Museum purchased many of the treasures in its graphics collection, were among the most prestigious of their kind in the United States and regularly featured renowned practitioners of the medium, including William Trost Richards, Thomas Eakins, Winslow Homer, John Singer Sargent, Cecilia Beaux, Maurice Prendergast, Arthur Dove, John Marin, Charles Demuth, Edward Hopper, Charles Burchfield, and Andrew Wyeth. Works by all of these artists are featured in this exhibition and the accompanying catalogue. Indeed, more than an opportunity to showcase these prized aspects of the Academy's holdings, this is an occasion to celebrate the Philadelphia Water Color Club's historical partnership with the Academy, which led to many important acquisitions.

During the past decade, special exhibitions of watercolors from the collections of the Metropolitan Museum of Art (1991), the Museum of Fine Arts, Boston (1993), the Brooklyn Museum of Art (1998), and the Munson-Williams-Proctor Institute Museum of Art (2000), among others, have demonstrated the special appeal and significance of the medium for scholars and the general public. With this exhibition, the Pennsylvania Academy adds its name to this distinguished roster. Many of the works in the collection are by familiar artists; many others, visitors will find, are not. As a whole, however, the collection is a testament to the foresight of past curators and directors who had the wisdom to collect works of high quality, widely and in depth. Instructors and students in the Academy's School have been studying this outstanding yet underrecognized resource since its inception. It is with great pleasure that we now provide the general public with its first major opportunity to explore and enjoy these riches.

Jonathan P. Binstock
Assistant Curator

[1] Theodore E. Stebbins, Jr., *American Master Drawings and Watercolors: A History of Works on Paper from Colonial Times to the Present* (New York: Harper & Row, 1976), xiv.

American Watercolors at the Pennsylvania Academy of the Fine Arts

Kathleen A. Foster
Curator, 19th- and 20th-Century Art
Indiana University Art Museum

Americans like watercolor, perhaps because we have all splashed with these paints in school. This sense of familiarity and accessibility is old and wide in the United States, where two hundred years ago watercolors were used by scores of children, amateurs, and almost every practicing artist—including architects, designers, engravers, and illustrators, as well as painters and sculptors. Literally the most popular medium in the United States, watercolor was nonetheless tainted by the aura of school projects and commercial uses. Handicapped by small scale and lightweight effects, watercolor paintings struggled for "serious" status in relation to the "higher" media of the European academic tradition. The story of acceptance and integration, complete and triumphant by the early twentieth century, can be read in the history of watercolor painting at the Pennsylvania Academy, where the pattern of exhibiting and collecting mirrors—with a local Philadelphia tint—the larger course of American taste.

Watercolor, like the idea of an Academy of the Fine Arts, came to Philadelphia from England, where the medium had been cultivated throughout the eighteenth century as a particularly national field of expression. The popularity of watercolor painting in Britain, carried to the United States by generations of immigrant or visiting British artists, artisans, and amateurs, and the power of British culture in Philadelphia's cultural institutions before the Civil War laid the foundation for the wide use of this medium in America. Just as watercolor progressed in Britain, overcoming preju-

dices that favored oil painting, so it also advanced in Philadelphia, but at a pace slowed by provincial conservatism and the smaller scale of the art community. In 1805, as a group of art-minded Americans gathered in Philadelphia to found the Pennsylvania Academy, a band of artists in London opened the first exhibition of the new Society of Painters in Water-Colours. In Philadelphia, it would be another six years before an artists' organization—the Society of Artists of the United States—staged its first annual exhibition of work in all media at the Academy, and almost a century would pass before the local watercolorists grew assertive enough to form their own club and promote their own specialized shows.

Between the time of the Academy's first "annual" in 1811 and the inaugural exhibition of the Philadelphia Water Color Club, held in the Academy's galleries in 1901, the style, technique, and function of watercolor painting were transformed. Although widely used in the early nineteenth century, watercolor was barely visible at the Academy before about 1850, as old-fashioned practices held sway. A visit to the exhibition of 1811 would have demonstrated the charms and disadvantages of the medium in this period. Overwhelmed by big, dark oil paintings and bright plaster casts of antique statuary, the watercolors huddled in the rotunda amid a motley display of prints, drawings, and "minor arts," generally undifferentiated in the catalogue.[1]

In this dignified public space, a case of pocket-size miniature portraits would have carried a disarmingly private, almost voyeuristic appeal. Edward Malbone, Anna

John Marin (1870–1953)
Sun, Sea, Land—Maine, 1921
Watercolor and charcoal on off-white wove paper
16½ x 19½" (41.91 x 49.53 cm)
Acquired from the Philadelphia Museum of Art (Samuel S. White, 3rd, and Vera White Collection) in partial exchange for the John S. Phillips Collection of European Drawings, 1985.21

Numbers cited in parentheses refer to catalogue numbers of figures.

Claypoole Peale, James Peale (8-9), Joseph Wood, and other miniaturists whose work appeared in the early exhibitions represented the largest class of professional watercolor painters in the country. From the late eighteenth century to the dawn of the photographic era in the 1840s, these miniaturists enjoyed a golden age. Many of them also made life-size portraits in oil and used the Academy's exhibition as a superb opportunity to win new customers. Despite the formal ambience of the galleries, the intimacy and luminosity of these small watercolors on ivory or vellum beamed a message from the world of the personal and the domestic. This same aura, elevated to royal realms, surrounds the oldest watercolor in the Academy's collection, a portrait from 1783 of *Prince Octavius* by Benjamin West (6). A local boy who rose to the rank of president of the Royal Academy and historical painter to King George III, West was the first honorary member of the Pennsylvania Academy. He painted the prince twice in oils for the royal family, but kept this watercolor for his own collection. The size and delicacy of the portrait suggest that the artist—who, like the king, was an affectionate father—felt unusually bereft by the death of four-year-old Octavius in 1783.[2]

A less personal and more imposing type of watercolor at the exhibition of 1811 came from another class of professional artist familiar with watercolor: architects. That year, Robert Mills and Benjamin Henry Latrobe both showed elevations and perspectives of work in progress on the capitols in Harrisburg and Washington. William Strickland, who had served as Latrobe's apprentice while he was renovating Philadelphia's New Theatre, drew upon his skills as an architectural draftsman and scene painter to depict the *New Theatre, Chestnut Street* (7) in 1808, just after William Rush's sculptures were installed in niches on the facade. Such views served as a splendid advertisement for his work and that of his master, offering architects an opportunity to showcase their talents in the Academy's galleries.

The welcome offered to architect-watercolorists in 1811 would endure. Beginning in 1887, a special gallery of architectural drawings became a featured part of the annual until 1893, when separate, parallel shows at the Academy were launched by the T-Square Club.[3] Architects from Drexel Institute of Technology (John J. Dull) and the University of Pennsylvania (Frank Miles Day and Alfred Bendiner [58]) showed their paintings alongside architectural views by Charles Edmund Dana, their colleague in the art department at Penn. Dana's work, including *School at Fribourg* (20), appeared at the Academy's annuals from 1883 until 1905, when he turned his energy to the presidency of the watercolor club and its shows. In the next generation, Bendiner's witty view of the world, from local street scenes to the university's archaeological excavations at Tikal, illuminated many exhibitions and publications from the 1930s until his death in 1964.[4]

In their different eras, Latrobe, Dana, and Bendiner were all watercolorists who demonstrated the utility of watercolor as the traveler's medium. The beauties of American and foreign scenery were frequently captured by watercolorists, often tourists such as W. J. Bennett and W. G. Wall, or immigrant British artists such as William Birch. Some of these watercolors were personal travel records, but most of these views had a professional agenda. A few may

have been "portrait" commissions by the owners of a mill or a country estate; others were made for or by printmakers who intended to publish. In addition, many artists prepared miniature vignettes and ornamental designs for the engraved certificates and bank notes that were the specialty of certain Philadelphia engraving firms (1). Thomas Sully (10), for example, exhibited fourteen watercolor designs for the "Arms of the United States" at the Academy in 1821.

The engravers, like the architects, worked in watercolor for both business and pleasure. John Sartain, who was a force at the Academy for the better part of the century, exhibited his miniatures, original watercolor designs, and the engravings made after them. Like many printmakers, Sartain also operated as a middleman, preparing wash reductions of larger paintings in preparation for engraving. Such copies were displayed at the Academy as a point of pride and promotion by many publishers. For engravers who were also designers, and for view painters, illustrators, and "translators" of imagery into printmaking formats, watercolor was both a working tool and their only exhibition medium.

The city's artist-naturalists, such as Charles Lesueur and Titian Peale, prepared exquisite watercolors "from nature" as documents of scientific research and travel, to be both engraved and exhibited at the Academy. Their work, beautiful in itself but prepared in watercolor with an eye to reproduction in the expedition report, joined a long tradition of ethnographic and scientific illustration in watercolor that continued in the nineteenth century with the western watercolor subjects of George Catlin, Karl Bodmer, and Seth Eastman (12).

Two kinds of private watercolors were rare in the Academy's early exhibitions, although they must have been numerous in Philadelphia. The first type included sketches made for personal delight or study by professional artists, perhaps recording domestic scenes, picturesque sites in Europe, or a planned composition. The young Charles R. Leslie had a memorable showing of such watercolors at the exhibition of 1811, where his four miniature portraits of actors, such as *Cooke as Richard III*, displayed so much promise that the Academy's directors were moved to raise funds to send him to London to study with West. Leslie's four "drawings" became the first watercolors to enter the Academy's collection; they were engraved (2) and displayed in the library until the turn of the twentieth century as a tribute to the beneficence of the directors and the success of a local artist who, like West, won a place in the Royal Academy.[5]

Leslie was only seventeen when his watercolors launched his career. His youthful effort points to another class of work, by students and amateurs, that appeared in the Academy's annuals from the outset, but not in numbers that accurately reflected the popularity of the medium. The first exhibition included watercolors of fruit, flowers, and shells by "a lady," probably akin to the *Wild Rose* (11) painted by Mary Douglass or Angela Kirkham in 1839. The kind of watercolor seen in Douglass's friendship album appeared rarely at the Academy, for such work was made to be shown in the domestic parlor, where it joined a display of miniatures, silhouettes, embroidered pictures, and other personal artifacts. Such pictures were unusual, too, in being created independently, done solely for personal delight and the pride of display, with no concern for patronage or a secondary goal, such as engraving.

This same kind of independent "exhibition watercolor" by professional artists was also rare at the Academy before 1850, and predictably the few examples shown were done by British immigrants or visitors accustomed to this new genre. In England, the prejudice against watercolor as a commercial or amateur medium had been overturned by the founding of watercolor societies and exhibitions, where a larger, more elaborate, and more forceful kind of watercolor was shown to compete convincingly with oil painting.

This new breed of watercolor arrived in Philadelphia in force after a disastrous fire in 1845 led to the refurbish-

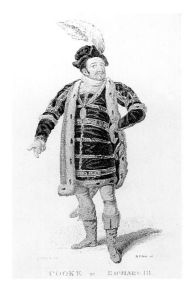

2
David Edwin (1776-1841)
[George Frederick]
Cooke as Richard III, 1810–11
Stipple engraving and engraving on off-white wove paper
8½ x 5⅛" plate (21.59 x 13 cm)
13⅜ x 10½" sheet (33.97 x 26.67 cm)
John S. Phillips Collection,
1876.9.249b

ment of the Academy's building and its programs. The directors launched a more rigorous school and an exhibition program that focused on contemporary art, including a notable surge in the display of drawings and watercolors. In 1853 the familiar hodgepodge in the rotunda shifted to the northwest gallery, where some twenty-seven watercolors by remarkably obscure artists appeared alongside sculpture. The number increased to forty-two in 1855, and the caliber of the exhibitors improved, with many watercolors by well-known English painters, such as Samuel Prout, John Callow, James B. Pyne, and Thomas Rowbotham, and a few French items by Eugène Delacroix and Gavarni, on loan from many local collectors. Suddenly, the *Crayon* could refer to a "Water-color room" at the Academy.[6] The following year the display jumped to 105 items, separately listed as "Water Color Drawings" in the catalogue, including a similar selection of mainstream Victorian watercolorists and a heartier group of locals, such as Thomas Moran, James Peale, Jr., F.O.C. Darley, and George H. Holmes. A few works came from a dealer, C. J. Price, but most of the pictures were lent by more than thirty private collectors, "evincing a special love for art in this direction on the part of Philadelphians."[7] The pioneering display of the short-lived New York Water Color Club at the Crystal Palace exposition in New York in 1853 may have fed this enthusiasm, or perhaps a proselytizer was at work. Samuel Fales, who lent many watercolors beginning in 1853, joined the Academy's board after another sizable group of watercolors appeared at the annual in 1857.[8]

This five-year pattern of increasing interest in the medium reached a crescendo in 1858 with the display of a new group of watercolors at the annual, from a new pool of lenders, followed by the sensational traveling exhibition of British art that visited three American cities in 1857-58. Most famous for its inclusion of Pre-Raphaelite work, the exhibition was dominated by middle-of-the-road English painting, including a substantial selection of watercolors by all the best-known artists of the day. Impressive in terms of the sheer quantity of pictures on view, the exhibition also included riveting work in watercolors, such as Ford Madox Brown's glittering *Looking Toward Hampstead* and John Ruskin's famous *Fragment of the Alps*, which persuasively demonstrated the attitudes and techniques put forward in Ruskin's influential manual, *The Elements of Drawing*. Ruskin's personal example, combined with the spellbinding quality of some of the Pre-Raphaelite painters he championed, galvanized several American artists who visited this exhibition. In Philadelphia, William Trost Richards was converted to "Ruskinism" on the spot and the following day began working from nature, with painstaking detail.[9]

Richards joined the American Pre-Raphaelite Brotherhood and shared their dedication to watercolor painting, the hallmark medium of the American Ruskinians. Members of the group lent their zeal—and a measure of controversy—to the early exhibitions of the American Watercolor Society, which was formed in New York in December 1866. Tolerant and eclectic, this society welcomed the Ruskinians, along with all the traditional constituencies that had been painting watercolors in the United States for decades: British immigrants, engravers and illustrators, architects and designers, amateurs and women, all seeking a more favorable forum for their work. This alliance received unexpected leadership from the landscape artists of the Hudson River School, who had learned to sketch and paint outdoors in the 1850s and understood the appeal of watercolor as a pleinair medium.[10]

Richards, the first Philadelphia watercolor painter to win a national reputation since the era of Benjamin West, became a powerful figure in the first generation of the American watercolor movement because he could bring together the English and the American traditions in landscape art. Trained in both academic and commercial art, and raised with an awareness of mainstream Victorian watercolors, he gradually transformed his work from the delicate, Ruskinian handling of *Rocks and Sea* of 1874 (13) to a broader, more

Turnerian grandeur. He would be surpassed on the national stage by another Philadelphian, Thomas Moran, who developed a dazzling style in watercolors by copying Turner's work in London. Adapting Turner's techniques to the sublime landscapes of the American West, Moran brought American watercolor into the realm of the spectacular.

Richards and Moran left Philadelphia in the 1870s, but their students and family members remained to carry on the English tradition. Richards's student Fidelia Bridges maintained a Ruskinian delicacy into the 1880s in works such as *Grass and Poison Ivy* (21), and Charles Fussell (14), an Academy student alongside Thomas Eakins in the 1860s, perpetuated Richards's careful technique in patiently lush watercolors painted at the turn of the century.

The stardom of Richards and Moran may have drawn other Philadelphians, such as Eakins, to the New York watercolor exhibitions of the early '70s, when the Academy's annuals were discontinued during construction of the new building on Cherry Street. The juries at the Watercolor Society welcomed artists who had been shut out of the stodgier National Academy of Design, and they allowed a wide range of styles, from the obsessive detail of the Pre-Raphaelites to the scandalous "impressionism" of Winslow Homer (16, 25). Eakins had mastered traditional wash techniques at Philadelphia's Central High School (3), but with typical caution he prepared oil studies in advance and then worked his figures in detail before washing in the background, as in *Retrospection*. Taking advantage of the luminosity of watercolor paper, his first efforts were sunny pictures of unconventional sporting subjects, which earned him a reputation as a watercolor painter well before his oils were known in New York. After 1881, Eakins used his camera to scout for surprising picturesque material along the Delaware, as in *Drawing the Seine*.[11]

Along with Eakins, Winslow Homer made his first appearance at the American Watercolor Society in 1874, seeking a forum to remake his reputation. Like many illustrators in the Society's exhibitions, he had used watercolor daily but sought opportunities to enlarge—or escape—the confines of his job. Another illustrator, born in Philadelphia and trained at the Academy, also made his debut at the watercolor exhibition of 1874: Edwin Austin Abbey. Much younger than Homer, Abbey was raised in a period of expanding prestige for the pictorial press, and he felt none of Homer's resentment. Delighted to be a staff artist at *Harper's*, he worked comfortably in ink and gouache to simplify the wood engraver's task, as in his illustration for Keats's *Eve of Saint Agnes* (19), published in *Harper's Monthly* in 1880.[12] With no experience in oil painting, he put his illustrator's technique to use in larger exhibition watercolors that displayed his talent for narrative and historical detail. The worldwide circulation of *Harper's* earned Abbey an international reputation that would win him a welcome at the Royal Water Colour Society and—like West and Leslie before him—at the Royal Academy.

The energy of the watercolor society drew Philadelphia's artists to New York and also fueled participation at home. A taste for sketches, promoted by the Philadelphia Sketch Club in its first exhibition in 1865, propelled experimentation in all the calligraphic media—watercolor, charcoal, pencil, pastel, pen and ink, and etching—that featured a personal and seemingly spontaneous revelation of the creative process. This interest, shared by both artists and collectors, led to the creation of special rooms of "Water Colors, Black & White, &c." in the annual exhibitions that recommenced after the opening of the Academy's new building in 1876. Eakins may have had a hand in the special loan exhibition of watercolors that opened in late 1877. Six of his works were among a selection of 292 items, including a few of the English watercolors seen twenty years earlier, about fifty pieces from American Watercolor Society regulars in New York, and a large turnout of local artists. The more progressive exhibitions of the Philadelphia Society of Artists, begun in 1879, also featured substantial collections

3
Thomas Eakins (1844–1916)
Thomas Crawford's "Freedom", 1861
Pen and ink and wash on cream wove paper, 13½ x 10⅜" (34.3 x 26.4 cm)
Charles Bregler's Thomas Eakins Collection. Purchased with the partial support of the Pew Memorial Trust and the John S. Phillips Fund, 1985.68.4.1

17

of work on paper, as did the Academy's special exhibitions, leading up to another large loan show of 380 English watercolors brought from London in 1886 by Henry Blackburn.

The phenomenon of the American watercolor movement, which reached its peak in the 1880s, extended to all corners of the art world, attracting older recruits from the Hudson River School, such as Worthington Whittredge (22), as well as younger artists influenced by the "impressionists" of Germany and Italy. Robert Blum, trained as a commercial artist in Cincinnati and briefly enrolled at the Academy, adopted the broad, wet style of contemporary Dutch, German, and Italian work in watercolors such as *Old Powhatan Chimney* (18), which pressed his *Scribner's* illustration assignment in Yorktown, Virginia, to avant-garde levels of suggestiveness.[13] The boldness of such work by Blum, Homer, Frank Currier, and others, building on the traditional appeal of watercolor as a sketch medium, inspired a second generation of watercolorists in the 1880s and 1890s—including Emile Gruppe, Childe Hassam, Maurice Prendergast (27), Theodore Robinson, and John Singer Sargent (26)—to press for effects of color and atmosphere on paper.[14]

In Philadelphia, Eakins's legacy was demonstrated in the work of his star students, among them Susan Macdowell and Philip Hahs (17), who may have attended extracurricular watercolor classes that Eakins first taught in 1875.[15] Cecilia Beaux, also a student in the late '70s, supported her early career with portraits painted on china, a technique akin to watercolor that led to her first exhibition pieces, such as the *Portrait of Edmund James Drifton Coxe* (24), shown at the Academy in 1884. Another student, Thomas Anshutz (23), also used watercolor in one of his debut entries at the Academy's exhibition of 1879. Like Eakins, Anshutz often used watercolor to echo the subjects of his oils and pastels, but some of his later outdoor subjects show an experimental sense of color and light that approached Fauve intensity.

The example of Moran, Abbey, Eakins, and Anshutz encouraged Philadelphia's students to pursue careers in illus-
tration and watercolor, fueling an era of expansion and innovation in American publishing, when the country's most talented artists were often employed by the illustrated press. Close behind Abbey came Howard Pyle, who also matured in the art department of *Harper's*. Pyle returned to Wilmington to found the "Brandywine School," which would endure in the Wyeth family into the present. Inspired by Pyle's imagination and decorative style, Maxfield Parrish turned to illustration and interior design in his last year as a student at the Academy in 1894. His first major project design, for a mural in the Mask and Wig Club at the University of Pennsylvania, was shown at the Academy's exhibition of architectural drawings in 1894–95 and was purchased for the permanent collection. Both playful and sophisticated, Parrish's jolly *Old King Cole* (29) demonstrates how watercolor painting flourished at the intersection of illustration and architectural decoration. The first watercolor acquired for the Academy since the similarly promising student work of Charles R. Leslie in 1811, *Old King Cole* marked the inauguration of the serious collecting of watercolors by the museum, as well as a golden age for Philadelphia's illustrators and designers.

The international stardom of alumni illustrators such as Abbey and A. B. Frost and the popularity of Pyle's courses at Drexel between 1894 and 1900 provoked the Academy to reconsider the long-held policy against teaching "applied" or commercial art. Two supplementary lectures on illustration were given in 1893 by W. Lewis Fraser of the *Century Magazine*, who returned to deliver a series of six "practical talks" in 1897 and again in 1898, concluding with "Modern Illustration: Its Place in the Fine Arts." Actual watercolor classes were offered in 1893–94 and 1894–95 by William S. Robinson. Further instruction in the medium ceased until the announcement in 1899 of "arrangements in progress" for illustration classes, followed by the brief appointment in 1899–1900 of the young *Scribner's* illustrator Walter Appleton Clark, who was charged with advancing "this branch to the

place it deserves in the modern Art School."[16] Clark departed and Henry McCarter took charge of the curriculum in illustration in 1900. A student at the Academy under Eakins, McCarter had built a successful career as an illustrator before turning his energies to teaching. His classes covered all the illustrator's media, including ink wash and watercolor, which dominated his own work until he adopted oil paints just before World War I. The matte tempera paints and decorative pattern in his *Yearly Tribute to the King of Tara* (32), shown at the watercolor exhibition in 1918,[17] demonstrate the combination of post-impressionist and arts-and-crafts sensibilities that made McCarter a progressive force at the Academy for forty years, as well as the mentor of many watercolorists and modernists of the next generation, such as Charles Demuth (38, 39) and Arthur B. Carles (43).

Women students also prospered in this era of expanding opportunities, making Philadelphia the "City of Women Illustrators."[18] Jessie Willcox Smith studied at the Academy, at Drexel, and at the School of Design for Women before building an international reputation as an illustrator of children's literature. *With Thoughtful Eyes* (30)—one of seven illustrations for Carolyn Wells's *The Seven Ages of Childhood*— was shown at the watercolor annual of 1909, displaying the delicate sentiment and refined technique that endeared Smith's work to both parents and children. Smith's friends and colleagues, Violet Oakley (4) and Elizabeth Shippen Green, shared her dedication to illustration and the book arts. Like Abbey, McCarter, and Parrish, Oakley also explored mural painting and decoration, using watercolor as a vehicle for many of her arts-and-crafts designs.

Oakley, Smith, and Green were among the founders of the Philadelphia Water Color Club, which presented its first annual exhibition in the galleries of the Pennsylvania Academy of the Fine Arts from November 30 to December 15, 1901. Twenty-four founding members, five honorary members (Abbey, Beaux, Sargent, John McClure Hamilton, and Joseph Pennell), and five "guests" (Jules Guérin, Albert Herter, Dodge MacKnight, F. Hopkinson Smith, and Horatio Walker) mustered 131 items for this inaugural show. Their endeavor reflected the strength of the community of watercolor painters in Philadelphia at the turn of the century, and also their complaints. Like the founders of the American Watercolor Society, they felt crowded and overshadowed at the usual annuals, where pressure from artists across the country made it increasingly difficult for local artists to gain entry. In New York, the Watercolor Society's exhibitions were growing more exclusive, as the members of the old guard protected their privileges, and a new group—the New York Water Color Club—had formed in 1890 to provide a forum for local painters. Philadelphia's watercolorists perhaps took courage from the example of this new club in New York, whose members included some of the founders of the Philadelphia club, and they were also encouraged by the success of watercolor shows at the Philadelphia Art Club, beginning in 1891.[19] From the standpoint of the Academy's management, these new developments afforded an opportunity to give focus to the sprawling annual.[20] Just as the architectural drawings had been delegated to the T-Square Club, so the watercolors could be spun off into a separate show. Discussion continued as the Philadelphia Water Color Club organized its own "second annual" exhibition at the Academy in March of 1903, while watercolors and other works on paper piled into the Academy's regular annual in escalating numbers. In January of that same year, the largest group of works on paper and miniatures—378—ever to appear in an annual contributed to the second-largest annual ever presented at the Academy, with a total of 931 objects.[21]

With relief and excitement on both sides, the separate shows under Academy sponsorship began in the spring of 1904, when the Philadelphia Water Color Club hosted the new "First Annual Philadelphia Water Color Exhibition." The promise of its earlier shows and the luster of the Pennsylvania Academy's endorsement at its moment of greatest prestige drew 597 works, almost four times the

4
Violet Oakley (1874–1961)
Study for Poster for PAFA Fourth Annual Philadelphia Water Color Exhibition, 1907
Conté crayon and graphite on cream wove paper
27⅞ x 16⅜" (70.8 x 41.59 cm)
Funds provided by the Women's Committee of the Pennsylvania Academy of the Fine Arts, 1978.10

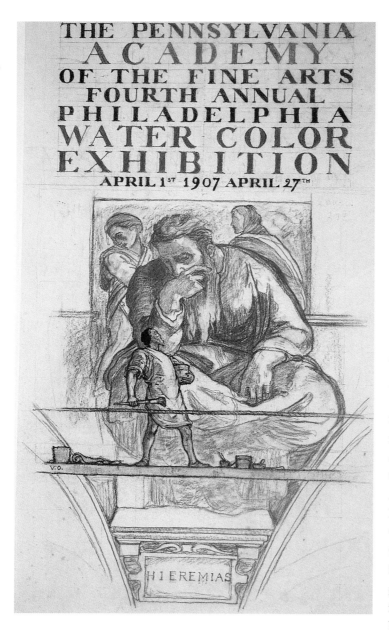

number in the club's previous display. Drawing upon the work of members, invited "guests," and juried independents, the show represented a cross section of the art community and an alliance of the medium's old constituencies. The founders—half of whom were women—included Academy faculty members Thomas Anshutz and Hugh Breckenridge and a mix of illustrators, designers, architects, landscape painters, and amateurs.[22] Although the show drew from a national pool, the majority of the exhibitors as well as the members were Philadelphia artists with local reputations, such as the club's president for its first decade, Charles Edmund Dana; his colleague at the University of Pennsylvania and successor as president for the next twenty-five years, George Walter Dawson (33); the seemingly per-petual vice-president, Blanche Dillaye; and steady exhibitors at both annuals, such as Marianna Sloan (28).

To lend distinction to the club's efforts, the stalwarts of the American Watercolor Society and the New York Water Color Club, among them William Trost Richards and Childe Hassam, were invited to contribute work. In 1905 seventy-two pictures from the American Watercolor Society's show held the previous month were hung en bloc in the north corridor. Collectors also were entreated to lend desirable pieces: in 1901 Samuel Bancroft, Jr., lent a collec-tion of the Pre-Raphaelite work that had inspired so many American watercolor painters and designers; in 1905 William Merritt Chase sent one of his watercolors of Holland, along with a Venetian subject by Sargent. Abbey showed work in the first exhibition; then *Harper's* lent examples of his Shakespearean illustrations. After Homer submitted large groups of Adirondack and Caribbean watercolors in the first few years, the club turned to local collectors, such as Dr. George Woodward, for views such as *North Road, Bermuda* (25).

The artists' enthusiasm for the watercolor annuals dou-bled the number of items exhibited, soon surpassing the total of all objects included in the earlier amalgamated annuals.

Although the numbers rose and fell, between 500 and 800 items by 125 to 250 artists usually appeared in these exhibitions.[23] These numbers reflected the inclusion of all kinds of works on paper—watercolors, drawings, pastels, prints—and, beginning with the eleventh exhibition in 1913, an alliance with the annual display of the Pennsylvania Society of Miniature Painters.[24] Previously shown in their own, separate annuals at the Academy, the miniatures represented the renaissance of this art in the late nineteenth century, when the revival of colonial art and architecture found a warm welcome in Philadelphia (5). "The miniature is the sonnet of portraiture," claimed the society's first president, Emily Drayton Taylor, "limited and proscribed, and yet the jewel of painting."[25]

Following the pattern of the Academy's regular annual, the Water Color Club soon established prizes for work shown in the exhibition. Rewarding excellent work done for color reproduction, the publisher Charles W. Beck, Jr., created the first prize fund in 1906; early winners included McCarter, Green, Parrish, Smith, Ernest L. Blumenschein, Thornton Oakley, and N. C. Wyeth. In 1915 the Philadelphia Water Color Prize was first awarded by the jury to the "strongest" work in the exhibition; Alice Schille, Dodge MacKnight, and Gifford Beal won in the first three years, followed later by Childe Hassam, Paul Gill (45), Earl Horter (40), Eliot O'Hara, and Charles Burchfield (48, 50), among others. In memory of Charles Edmund Dana, the Dana Water Color Medal was established in 1918 to recognize "boldness, simplicity, and frankness of work" in watercolor; over the years, this prize went to Charles Demuth, Reginald Marsh (46), and Andrew Wyeth (66); in 1965 it was awarded to Zsissly (Malvin Marr Albright) for the hallucinatory still life, *The Trail of Time is Dust* (55). Beginning in 1938, in memory of George Walter Dawson's celebrations of flowers and gardens (such as *The Rose and Lily Walk* [33]), the Dawson Memorial Medal was awarded to work in a similar vein by artists such as Hobson Pittman (57) and

Philip Jamison, whose *Plummer's Lilies* won in 1959. Finally, in 1945 the Philadelphia Water Color Club Medal of Honor was founded to recognize lifetime achievement or "the Advancement of Water Color Art" by an individual or an institution. First given to the Pennsylvania Academy, this award later honored distinguished artists such as John Marin (36), Henry C. Pitz (56), Walter Reinsel, Dong Kingman, and Morris Blackburn (42).[26]

A special purchase fund created in 1928 and the occasional use of the Philadelphia Water Color Prize as a purchase prize brought watercolors into the permanent collection of the club, but not to the Academy, where the traditional purchase funds were dedicated to work shown at the "regular" annual. Circumventing this restriction, the Academy acquired watercolors from those who exhibited in both annuals. *End of the Day* (48), a Temple Fund purchase from the paintings annual in 1940, demonstrates the force of Burchfield's work—and the potential of modern watercolor—in any arena. After 1955, when the annuals began to alternate between "watercolors" and "painting and sculpture," the Gilpin and Lambert purchase funds were devoted to works on paper in alternate years. In this new system, Burchfield's *Purple Vetch and Buttercups* (50), along with work by John Chumley, Chen Chi, Dong Kingman, Philip Jamison, and Henry Pitz, was acquired for the collection from the watercolor annual.[27]

As the era of the Philadelphia Water Color Club opened, two successful generations of serious watercolor artists had transformed American notions about watercolor. With the example of Homer and Sargent before them, younger artists picked up watercolor naturally, some of them to earn a living in illustration or design, others to advance impressionism, and a still younger group to test the concepts of modernism. In New York, almost every painter in the circle of Alfred Stieglitz worked adventuresomely in watercolor, particularly Marin, Arthur Dove (37), and Georgia O'Keeffe. Modernism surged at the Academy under the

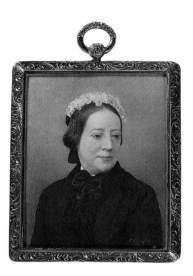

5
Emily Drayton Taylor (Mrs. J. Madison
Taylor) (1860–1952)
Mrs. Charles Wallace Brooke
1894
Watercolor on ivory
2⅜ x 1¹³⁄₁₆" (6.03 x 4.6 cm)
Bequest of William Brooke Rawle,
1927.12.3

supervision of Anshutz and McCarter, who taught Blackburn, Demuth, and Marin, along with Arthur B. Carles, George Luks (34), and many others who turned watercolor to modern styles and subjects. Demuth worked with equal charm and authority in oil, tempera, and water-color, producing cubist architectural scenes, such as *Box of Tricks* (38), as well as sensuous flower subjects, such as *Gladiolas* (39), that would earn him the Dana Water Color Medal in 1926.[28]

Carles and his friends would challenge Philadelphia's increasingly conservative taste with a series of innovative exhibitions at the Academy that began in 1919 with a water-color annual that "omitted no extremist." With Carles and Demuth on the jury, the display included a flood of artists from "the hectic school" of Marin, Davies, Henri, and other younger moderns.[29] The following year the exhibition *Representative Modern Masters* brought avant-garde work from New York and Paris, including a remarkable number of watercolors by Paul Cézanne, André Derain, Albert Gleizes, Marie Laurencin, Henri Matisse, and Pablo Picasso. A sec-ond exhibition, in 1921, *Later Tendencies in Art*, featured modernists from New York and Philadelphia. The show received good reviews in the art press, but a third show, in 1923, of Albert Barnes's avant-garde collection proved a critical disaster. The organizers, lenders, and supporters of these shows retreated, and Philadelphia's—and the Academy's—reputation as a progressive national showplace dimmed.[30]

More sympathetic to Philadelphia's academic tastes, the American Scene painters took center stage in the 1930s, finding a welcome among the watercolor painters who maintained the tradition of Homer and Sargent, including John Dull, Paul Gill, Ogden Pleissner, and Andrew Wyeth. Some, like Blackburn, Burchfield, Edward Hopper (49), and Reginald Marsh, reconfirmed the old link between illustra-tion, commercial design, and watercolor, learning a visual language in the workplace that could later be turned to suc-

cessful exhibition work. Others, like Andrew Dasburg (41) and Ben Shahn (52), rediscovered realism and social commentary after experimenting with modernism. Many painters, including Burchfield, Jacob Lawrence (67), and Wyeth, built distinguished careers based almost entirely on work in watercolor or tempera. Others, such as Marin, Demuth, and Hopper, were well known (or perhaps pre-ferred) for work in watercolor.

At the watercolor annual of 1932, Stuart Davis's *Sand Cove* (47), with its fusion of synthetic cubism, surrealism, and American landscape forms, demonstrated the path of modernism that would lead in the 1940s from Arshile Gorky and Jackson Pollock to abstract expressionism. The larger scale of such work might seem to exclude adventuresome-ness in watercolor, but the splashiness and calligraphic appeal of the medium drew the attention of artists such as Milton Avery (44), Franz Kline (62), Hans Hofmann (60), Sven Lukin, Robert Motherwell (63), Sonia Sekula, and—more recently—Sam Gilliam (79). For committed modernists with a Bauhaus interest in design, such as Alexander Calder (59), watercolor remained—as it had been in the past—the inter-section of ideas in many media, including jewelry, textiles, and prints.

The Academy discontinued the annuals in 1969, swamped by the scale and expense of a national juried show. It was a good time to quit. Already torn between traditional and progressive wings, the art world was beginning to frag-ment into multiple "avant-gardes," as modernism itself became the object of ironic play and then downright attack. This phenomenon, postmodernism, made any encyclopedic exhibition of contemporary trends look chaotic, but it was invigorating for works on paper and all the "alternate" media that rose up to challenge the authority of large-scale abstract paintings and sculptures. The revival of all types of prints and drawings in the 1960s showed a hip, democratic impulse, based on the imagery of popular culture as well as the realities of the marketplace. Like the watercolor painters

of the 1870s, artists recognized an educated, middle-class audience hungry for smaller, less expensive work. Domestic in scale, but with all the impact of a salon painting, the "exhibition" watercolor was reborn in the work of Philip Pearlstein (65), Elizabeth Osborne (70), and Joseph Raffael (69). Watercolors have offered access to the thoughts of a sculptor, such as Mary Frank (71), and the stirring record of a temporary or even imaginary project, as envisioned by Robert Stackhouse (77) or Christo and Jean-Claude. As in the past, the calligraphic immediacy of ink wash or water-color continues to reveal the creative moment, as the acute observation of landscape masterfully turns to abstract form in Alfred Leslie's *Coal Pile near the Ohio River* (64), or as private narratives become playfully, provocatively visible in the work of Gladys Nilsson (74), Jody Pinto (73), and William T. Wiley (78).

The tradition of the purchase prize lives on in the Academy's annual Fellowship Exhibition, which brought Shoji Okutani's enigmatic landscape of 1987 into the collection. Otherwise, the death of the annuals in 1969 ended the automatic acquisition of contemporary art through exhibition purchase prizes, which had made the Academy's permanent collection such a treasure of both taste and accomplishment in "contemporary" American art since the 1880s. Efforts to maintain and improve that tradition by acquiring new work and filling old gaps can be read in the list of work in the present book and the accompanying exhibition, almost half of which is composed of gifts and purchases made since 1970. The pace of acquisitions in the last thirty years testifies to the enduring, even accelerating popularity of the medium among artists, collectors, and curators as the Academy approaches its two hundredth birthday. Some tantalizing gaps in the collection remain, but they have been closed in the present survey by generous loans from local collections. Together, the ensemble illustrates the richness of Philadelphia's record in watercolor and bears witness to the abiding American affection for this medium.

The author is grateful for assistance in the preparation of this text from Cheryl Leibold, the Academy's patient and resourceful archivist, and Jonathan Binstock, the museum's assistant curator and organizer of the exhibition. Time out of mind, when research on this collection anticipated a published catalogue of the Academy's entire graphic arts collection, I was assisted by Elizabeth Milroy, Helen Mangelsdorf, Judy Stein, Catherine Stover, Jeannette Toohey, and Cynthia Haveson Veloric, whose work is gratefully remembered.

NOTES

1. Study of the Academy's exhibitions is hampered by the lack of information in the published catalogues, which inconsistently record information about medium. A brief history of the annual exhibitions is given in the "Introduction to the Revised Edition" and "Foreword" to Anna Wells Rutledge, *The Annual Exhibition Record of the Pennsylvania Academy of the Fine Arts, 1807–1870* (Madison, Conn.: Sound View Press, 1988). See also Cheryl Leibold, "A History of the Annual Exhibitions of the Pennsylvania Academy of the Fine Arts: 1876–1913," in vol. 2 of this series (Sound View Press, 1989), 7–32. On the larger history of American watercolors and an extended bibliography, see Theodore E. Stebbins, Jr., et al., *American Master Drawings and Watercolors: A History of Works on Paper from Colonial Times to the Present* (New York: Harper & Row, 1976).

2. See Helmut von Erffa and Allen Staley, *The Paintings of Benjamin West* (New Haven and London: Yale University Press, 1986), 480. West, like most of the Philadelphia artists in the present book, is profiled in the Philadelphia Museum of Art's bicentennial catalogue, *Philadelphia: Three Centuries of American Art* (1976), an indispensable dictionary and bibliography of local artists that includes many of the miniaturists and watercolor painters mentioned in this essay.

3. Leibold, "A History of the Annual Exhibitions," 14. The T-Square "annuals" had their own catalogues, which are not indexed in the Academy's published exhibition records. On the history of these shows and the larger tradition of architectural drafting in Philadelphia, see James F. O'Gorman et al., *Drawing Toward Building: Philadelphia Architectural Graphics, 1732–1986* (Philadelphia: University of Pennsylvania Press, for the Pennsylvania Academy of the Fine Arts [hereafter PAFA], 1986). "Because the T-Square Club adhered to the Morris belief in the alliance of all arts in architecture, the[ir] exhibits included a broad range of architectural sculpture, sketches, and studies and cartoons for murals and stained glass as well as archaeological studies, travel sketches, plans, elevations, perspectives, and fully rendered and developed competition drawings." George E. Thomas, in *Drawing Toward Building*, 122. The Philadelphia Art Club also staged shows of architectural drawings, beginning in the 1890s.

4. Dana's watercolor, dated 1890, may be the subject titled *Schoolhouse, Style of Louis XV, Fribourg, Switz.*, shown at the 1891 annual. It also appeared in the watercolor annual of 1906 as *An Old Doorway: Fribourg*.

5. The perpetual exhibition of these watercolors is tracked in Rutledge, *Annual Exhibition Record*, 126–27. Last listed in a catalogue of the permanent collection in 1897, the watercolors were "disposed of" in 1950.

6. "Sketchings," *Crayon* 1 (May 16, 1855): 314.

7. "Sketchings," *Crayon* 3 (July 1856): 218.

8. On the first New York Water Color Club, see Albert T. E. Gardner, *A History of Watercolor Painting in America* (New York: Reinhold, 1966), 11–12.

9. See Susan P. Casteras, "The 1857–58 Exhibition of English Art in America," and Kathleen A. Foster, "The Pre-Raphaelite Medium: Ruskin, Turner, and American Watercolor," in *The New Path, Ruskin and the American Pre-Raphaelites* (Brooklyn: Brooklyn Museum, 1985), 109–33, 78–107.

10. On the formation of the American Watercolor Society, see Kathleen A. Foster, "Makers of the American Watercolor Movement, 1860–1890" (Ph.D. diss., Yale University, 1982), 1–40.

11. On Eakins's watercolors, see Kathleen A. Foster, *Thomas Eakins Rediscovered* (New Haven: Yale University Press, 1998), 81–97.

12. Engraved by Henry Wolf, the picture was published in *Harper's* 60 (January 1880): 173. The subject, made famous in Abbey's youth by one of his heroes, the Pre-Raphaelite painter Holman Hunt, depicts the flight of Madeline and Porphyro, who "glide, like phantoms, into the wide hall."

13. This watercolor and another one at PAFA, *Principal Street of Yorktown*, were done on assignment from *Scribner's* in 1879–80 and published as wood engravings by A. Hayman and A. Whitney in "Old Yorktown," *Scribner's* 22 (October 1881): 813, 802.

14. On the watercolor movement in the 1880s, see Foster, "Makers of the American Watercolor Movement"; the story of the watercolor movement from the vantage point of the great collections in Boston and Brooklyn has been told in Sue Welsh Reed and Carol Troyen, *Awash in Color: Homer, Sargent, and the Great American Watercolor* (Boston: Museum of Fine Arts, 1993), and Linda Ferber and Barbara Dayer Gallati, *Masters of Color and Light: Homer Sargent and the American Watercolor Movement* (Brooklyn: Brooklyn Museum of Art, 1998).

15. These classes were initiated at the Sketch Club, at the request of students, prior to the recommencement of classes at the Academy in 1876. It is not known how long they continued, although Eakins's impact is clear in the work of Macdowell in 1879 and of Hahs in 1881–82. See Gordon Hendricks, *The Life and Work of Thomas Eakins* (New York: Grossman, 1974), 85.

16. *Ninety-third Annual Report, February 6, 1899, to February 5, 1900* (Philadelphia: PAFA, 1900), 16. The "arrangements" seem to have included an invitation to Maxfield Parrish, who declined the job; see Parrish to Harrison Morris, April 28,1899, PAFA Archives.

17. This piece may be the item exhibited as *Tribute to the King* at the Academy's regular annual in 1907. On McCarter, see the Academy's school circulars from this period, and Anne d'Harnoncourt, "Henry Bainbridge McCarter," in *Philadelphia: Three Centuries of American Art*, 560–61.

18. "Young Women Illustrators and Their Work," *Philadelphia Times*, June 2, 1901, PAFA clippings scrapbook. See also Christine Jones Huber, *The Pennsylvania Academy and Its Women, 1850 to 1920* (Philadelphia: PAFA, 1973).

19. The Art Club, formed in 1887, began annual exhibitions of painting and sculpture in its new building at Broad and Chancellor Streets in 1890. An annual show of "watercolors and pastels" commenced in 1891. Early catalogues from this series are at the Free Library of Philadelphia and on microfilm at the Archives of American Art, Smithsonian Institution, Washington, D.C.

20. Colin Campbell Cooper and his wife, Emma Lambert Cooper, as well as Violet Oakley and Jessie Willcox Smith, were all members of the New York Water Color Club; many other Philadelphia club members exhibited at the NYWCC, and the New York group regularly showed at the Academy's annuals, particularly after William Trost Richards complained to Harrison Morris about the "character" of the watercolor display and suggested contacting the New York societies; see Richards to Morris, March 12, 1895, PAFA Archives. Correspondence between Henry B. Snell, president of the NYWCC, and PAFA's Harrison S.Morris, drawn to my attention by Cheryl Leibold, indicates that work from the New York show was forwarded en bloc to the Academy the following year. Snell also complained that the watercolors were too crowded at PAFA and thus "not displayed to advantage," which discouraged entry of "the best pictures." See Snell to Morris, June 2, 1896, and September 28, 1898.

21. See the table of exhibition entries in Leibold, "History of the Annual Exhibitions,"33. Although no writer has studied the decision to separate the works on paper and miniatures from the paintings and sculpture, "it is clear that the jury, as well as Harrison S. Morris [managing director of PAFA] felt that this section contained a higher percentage of work by local artists and amateurs. In addition, the work tended to be small, thus increasing the overall hanging difficulties." Segregating the work and delegating some organizational aspects to the club did not, however, reduce the workload for the Academy staff, which saw the number of works handled each year almost double. Leibold, 25.

22. The category of "guests" was published in the club's catalogues of 1901 and 1903 and then abandoned, although it seems that much work continued to be invited to the exhibition, outside of the jury's review, as was the practice with the painting and sculpture annuals.

23. Some of the early catalogues record more than a thousand entries, although these numbers misrepresent the total in the exhibition, since each gallery recommenced the numbering at the next hundred level, even if less than a hundred items appeared in the previous room.

24. Miniatures appeared in the annuals in accelerating numbers at the turn of the century, capped by the importation in 1903 of the entire annual show of the Society of Miniature Painters of New York. The Pennsylvania society was established in 1901 and staged four annual exhibitions in local art galleries before holding its fifth show at the Academy, concurrent with the watercolor annual of 1906. In 1913 the two clubs published their first joint catalogue, and they continued to show together until the miniature society held its fiftieth, and final, exhibition in the fall of 1951. In 1913 the membership included one man and twenty-five women. Like the Academy's other annuals, the display included invited work by members, as well as a juried component. The miniatures were listed together and shown in one gallery. For many years the society also held a smaller show in the fall, for members only, at the Philadelphia Art Alliance.

25. "The Miniature," in *Catalogue of the Fifth Annual Exhibition* (Philadelphia: PAFA and the Pennsylvania Society of Miniature Painters, 1906), 5. The tenth and twenty-fifth anniversary exhibitions of the miniature society in 1911 and 1926 were enlarged to include special historical displays; in 1921 the twentieth annual exhibition featured a loan show from the Royal Miniature Society of London. Complementary displays of medieval illumination from the collection of the Academy's president, John F. Lewis, were occasionally mounted alongside the annuals in these years, nurturing the Pre-Raphaelite sensibilities of Philadelphia's large community of illustrators and book designers. See *The Pennsylvania Society of Miniature Painters* (Philadelphia, 1933), an unpaginated pamphlet in the PAFA Archives.

26. Cumulative lists of prizes were published in every catalogue, so the final catalogue in 1969 carries the complete roster. These prizes, as well as the entries in the watercolor, miniature, and architectural drawing annuals, are not included in the published directories of the annual exhibition records of the Pennsylvania Academy. Research into these records is complicated by the mixture of work in different media in the catalogues and exhibitions, often without description of the technique; this makes it difficult to sort the work of artists submitting items in more than one kind of medium, or to track how many watercolors (or prints, pastels, etc.) were shown. The catalogues can be consulted at the Academy's Archives and have been microfilmed by the Archives of American Art.

27. The annual of 1955, celebrating the Academy's 150th anniversary, was a special historical survey of American art. No watercolor annual was staged in 1956; the first of the alternating exhibitions of watercolors was held in 1957 and in the spring of every odd-numbered year through 1969. Meanwhile, in the fall of the odd-numbered years from 1955 to 1967, the Philadelphia Water Color Club held a smaller exhibition, for members only, at the Academy. In the even-numbered years, the club presented a watercolor "annual" at another site. The club's papers, held privately, have been microfilmed by the Archives of American Art.

28. Demuth showed steadily at the watercolor annuals, exhibiting forty-eight items between 1912 and 1934, the year before his death, when he served on the jury for the second time.

29. *Philadelphia Ledger*, November 9, 1919, PAFA clippings scrapbook.

30. On these exhibitions, see Sylvia Yount and Elizabeth Johns, *To Be Modern: American Encounters with Cézanne and Company* (Philadelphia: PAFA, 1996).

6
Benjamin West (1738–1820)
Portrait of Prince Octavius, 1783
Gouache over black chalk on buff laid paper
23 5/16 x 16 5/8" (59.21 x 42.23 cm)
Gift of Bernice McIlhenny Wintersteen,
1983.16

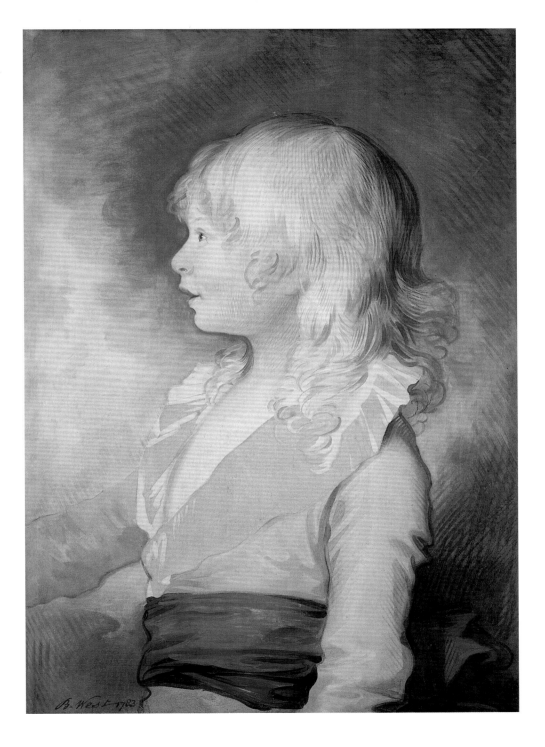

7

William Strickland (1788–1854)
New Theatre, Chestnut Street, 1808
Watercolor and ink on off-white paper
25½ x 33½" (64.77 x 85.09 cm)
Gift of Mr. and Mrs. William Jeanes,
1975.19

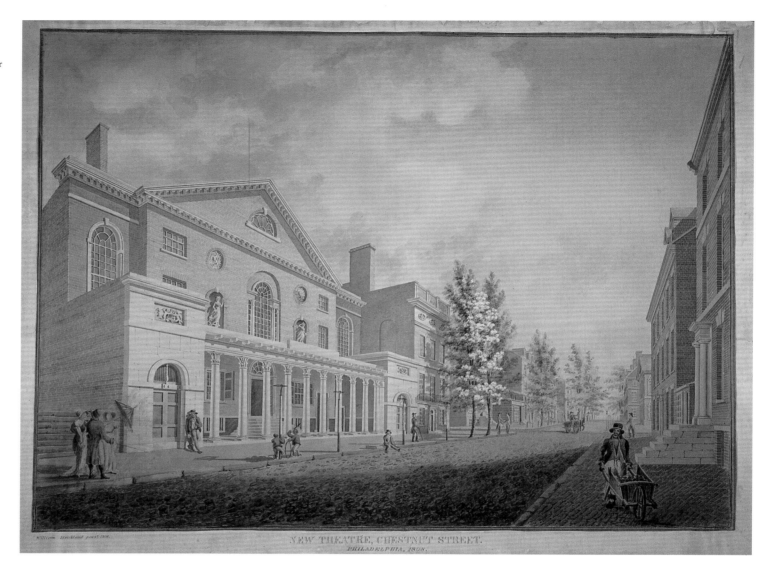

NEW THEATRE, CHESTNUT STREET.
PHILADELPHIA, 1808.

26

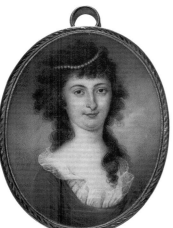

8

James Peale (1749–1831)
Frances Gratz Etting, 1794
Watercolor on ivory
2⅜ x 1⁹⁄₁₆" (6.03 x 3.97 cm)
Gift of Frank Marx Etting, 1886.1.4

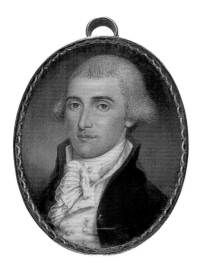

9

James Peale (1749–1831)
Reuben Etting, 1794
Watercolor on ivory
2⁷⁄₁₆ x 1¹³⁄₁₆" (6.19 x 4.6 cm)
Gift of Frank Marx Etting, 1886.1.5

10

Thomas Sully (1783–1872)
Three Classical Figures, ca. 1810
Watercolor on cream wove paper
9 x 6¾" image (22.86 x 17.15 cm)
Gift of Theodor Siegl, 1962.26.2

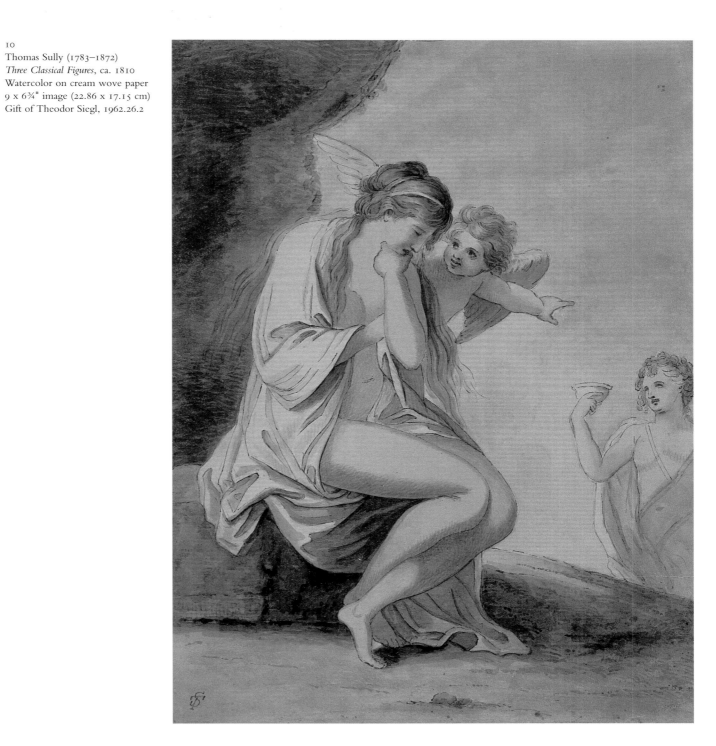

11
Attributed to Mary Douglass
(dates unknown)
Wild Rose, 1839
Watercolor, graphite and ink on off-
white wove paper
7⁷⁄₁₆ x 5¹⁵⁄₁₆" (18.9 x 15.08 cm)
Sales Desk Development Fund
Purchase, 1969.25.5

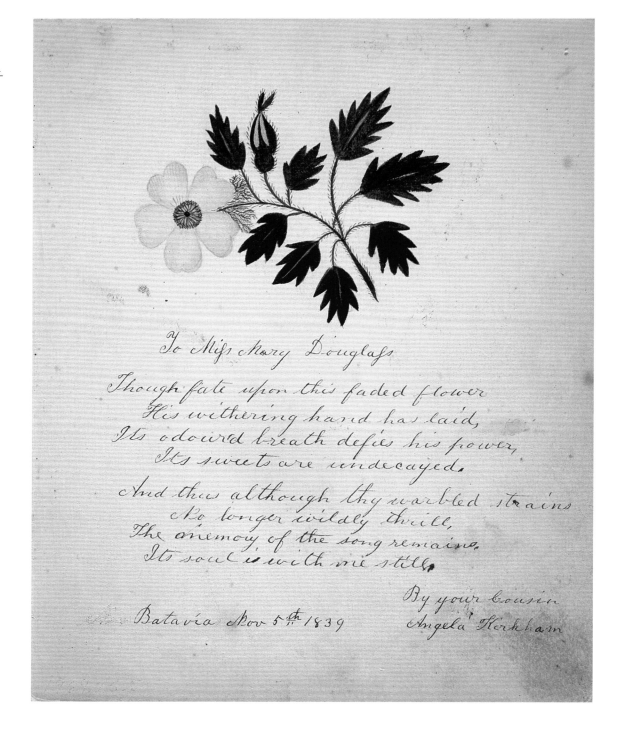

To Miss Mary Douglass

Though fate upon this faded flower
His withering hand has laid,
Its odour'd breath defies his power,
Its sweets are undecayed.

And thus although thy warbled strains
No longer wildly thrill,
The memory of the song remains,
Its soul is with me still.

By your cousin
Angela Kirkham

Batavia Nov 5th 1839

12
Seth Eastman (1808–1875)
Indians in Camp, 1848
Watercolor and graphite on
off–white paper
8¼ x 7⁷⁄₁₆" (20.96 x 17.94 cm)
1982.x.17

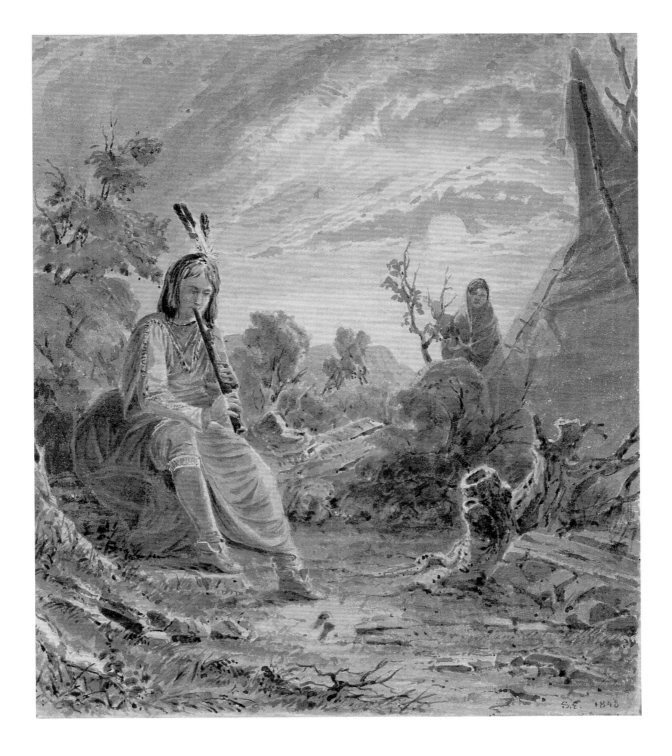

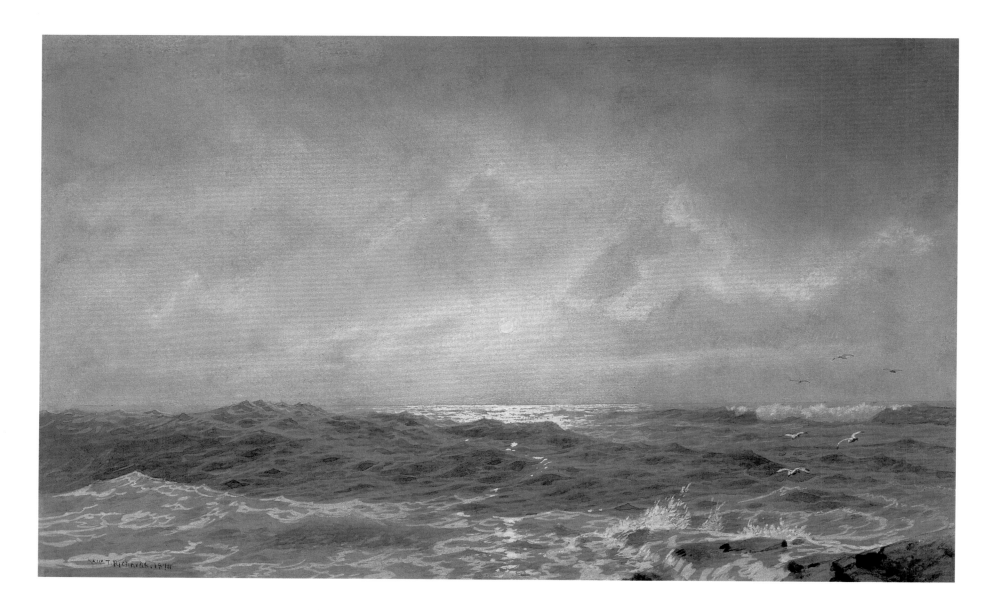

13
William Trost Richards (1833–1905)
Rocks and Sea, 1874
Watercolor on gray Bristol board
8½ x 13¹⁵⁄₁₆" (21.59 x 35.4 cm)
Gift of Mr. and Mrs. H. Lea Hudson
in memory of Mr. and Mrs. George
Farnam Brown, 1973.17.2

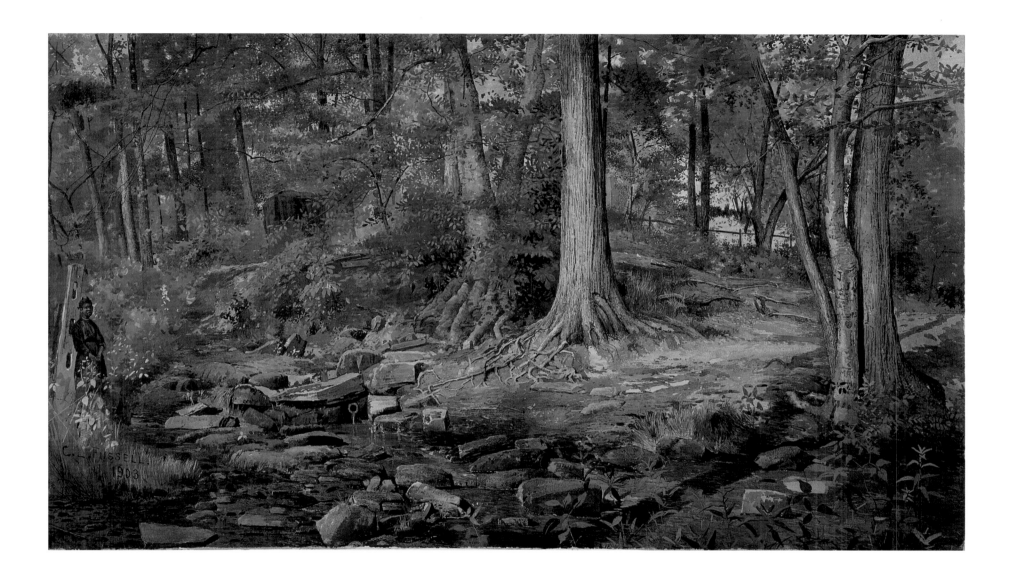

14
Charles Lewis Fussell (1840–1909)
Young Girl at Forest Spring, 1903
Watercolor and gouache on cream
wove paper
14 x 23⅞" (35.56 x 60.64 cm)
Gift of Mrs. Henry M. Fussell, 1974.8

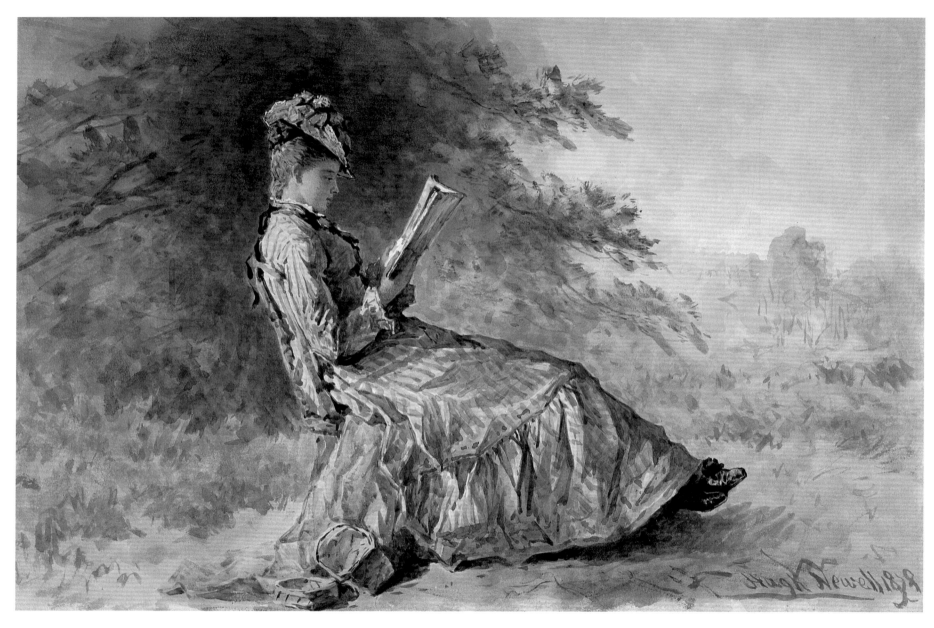

15
Hugh Newell (1830–1915)
Seated Girl Reading, 1878
Watercolor on cream wove paper
15¼ x 22⁵⁄₁₆" (38.74 x 56.67 cm)
Henry D. Gilpin Fund, 1973.11

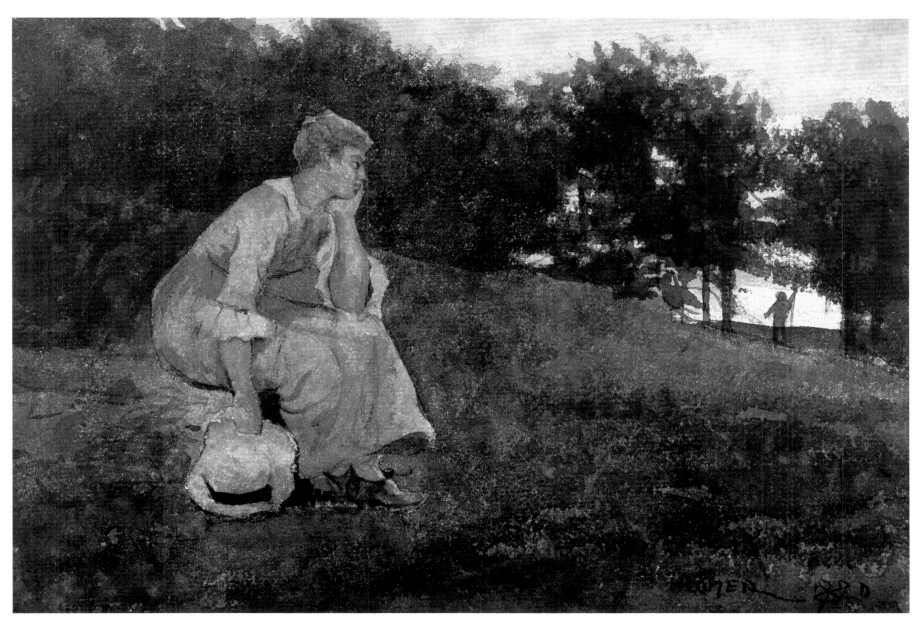

16
Winslow Homer (1836–1910)
Waiting, 1880
Watercolor on paper
8½ x 12½" (21.59 x 31.75 cm)
Courtesy of CIGNA Museum and Art Collection

17
Philip B. Hahs (1853–1882)
Old Recollections, 1882
Watercolor on off-white wove paper
14⁷⁄₁₆ x 10³⁄₈" (36.67 x 26.35 cm)
Gift of Mrs. Charles B. Hahs, 1884.2.1

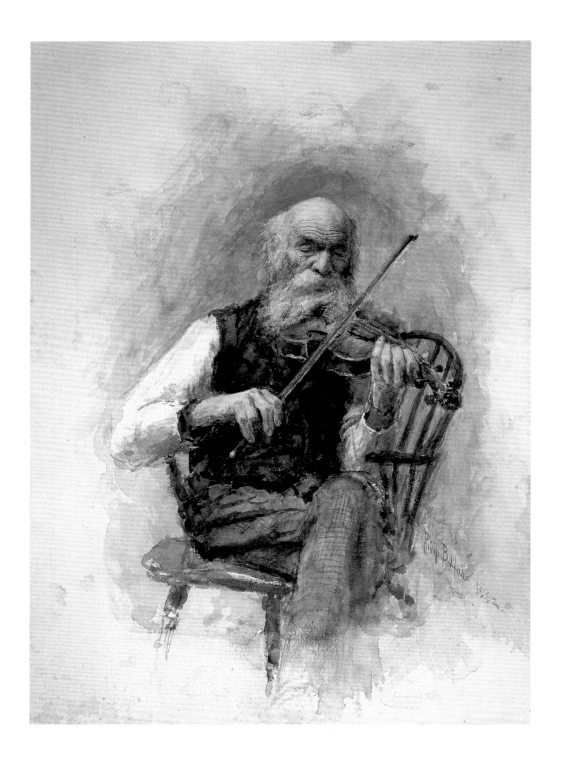

18
Robert F. Blum (1857–1903)
Old Powhatan Chimney, 1879–80
Watercolor, Chinese white and
graphite on cream watercolor paper
9⅛ x 7½" (23.18 x 19.05 cm)
Gift of Mrs. James Mapes Dodge,
1951.30.1

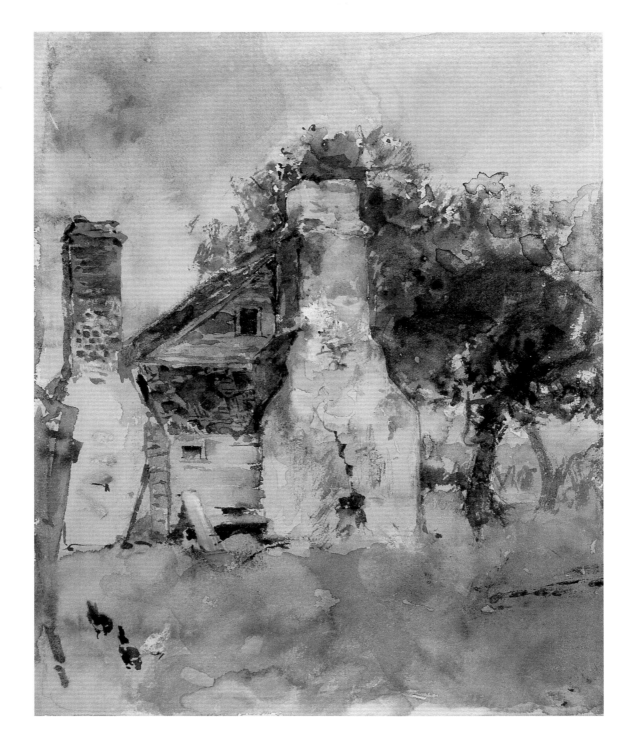

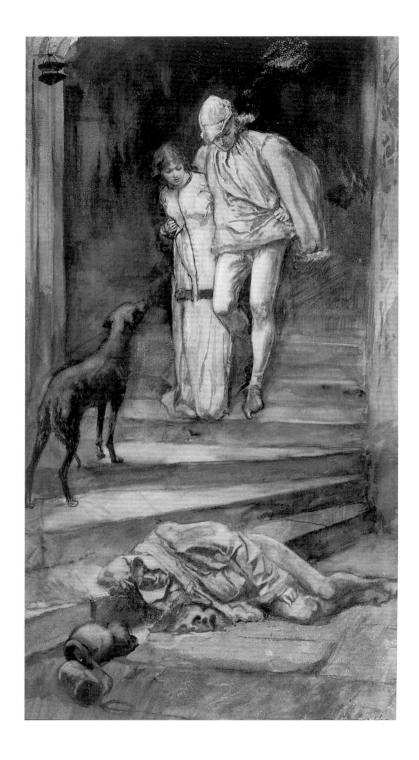

36

20
Charles Edmund Dana (1843–1914)
School at Fribourg, 1890
Watercolor over graphite on off-white
wove paper
21⅛ x 14⁹⁄₁₆" (53.66 x 36.99 cm)
Gift of the artist, 1915.1.2

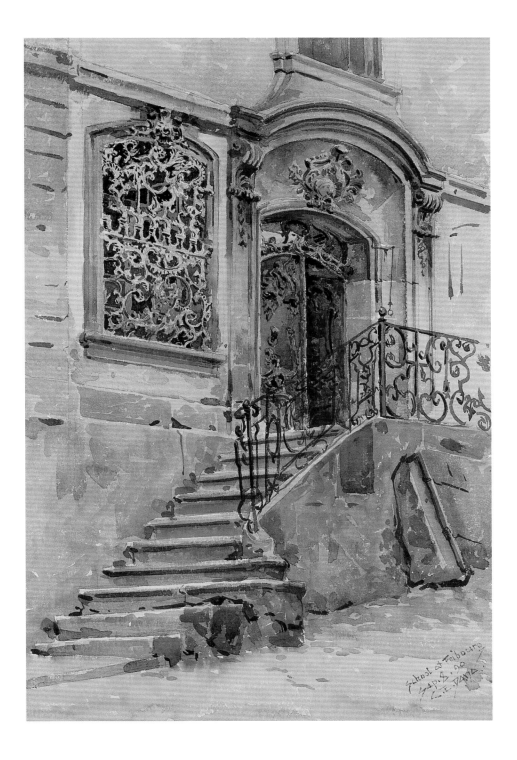

21
Fidelia Bridges (1834–1923)
Grass and Poison Ivy, ca. 1880
Gouache and watercolor on off-white
wove paper
13 15/16 x 10" (35.40 x 25.4 cm)
Henry D. Gilpin Fund, 1983.1

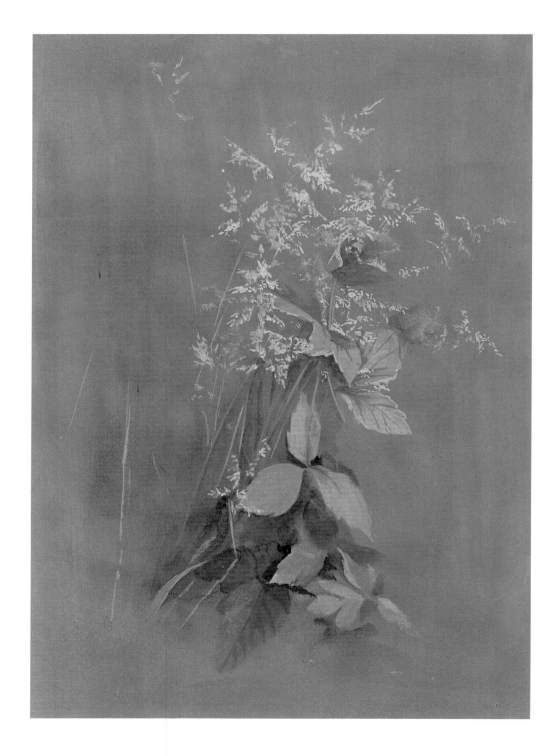

22
T. Worthington Whittredge (1820–1910)
Laurel Blossoms in a Blue Vase, ca. 1890
Watercolor on white paper
15 x 10½" (38.1 x 26.67 cm)
Gift of Mr. and Mrs. Edward Kesler,
1975.20.1

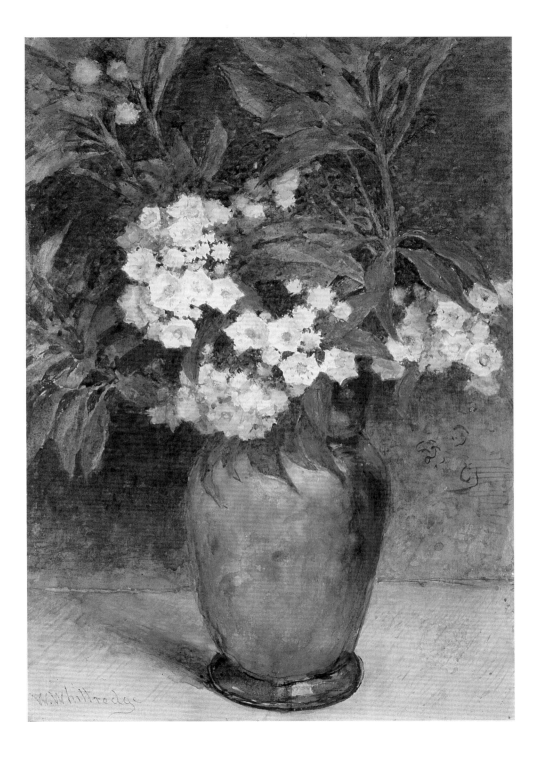

23
Thomas Anshutz (1872–1912)
Untitled, ca. 1890
Watercolor on cream watercolor paper
27⅞ x 15" (70.80 x 38.1 cm)
Gift of Mrs. Edward Anshutz,
1971.8.69

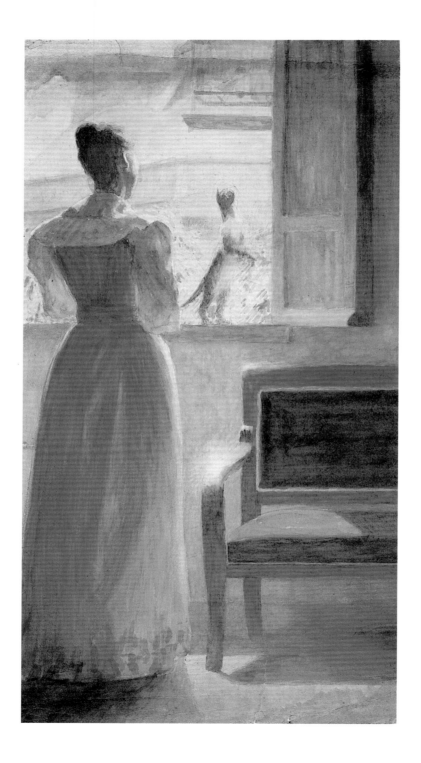

24
Cecilia Beaux (1855–1942)
Portrait of Edmund James Drifton Coxe,
1884
Watercolor on heavy wove paper
24⅛ x 18¼" (61.29 x 46.36 cm)
Gift of Maria M. Skinner, 1992.6

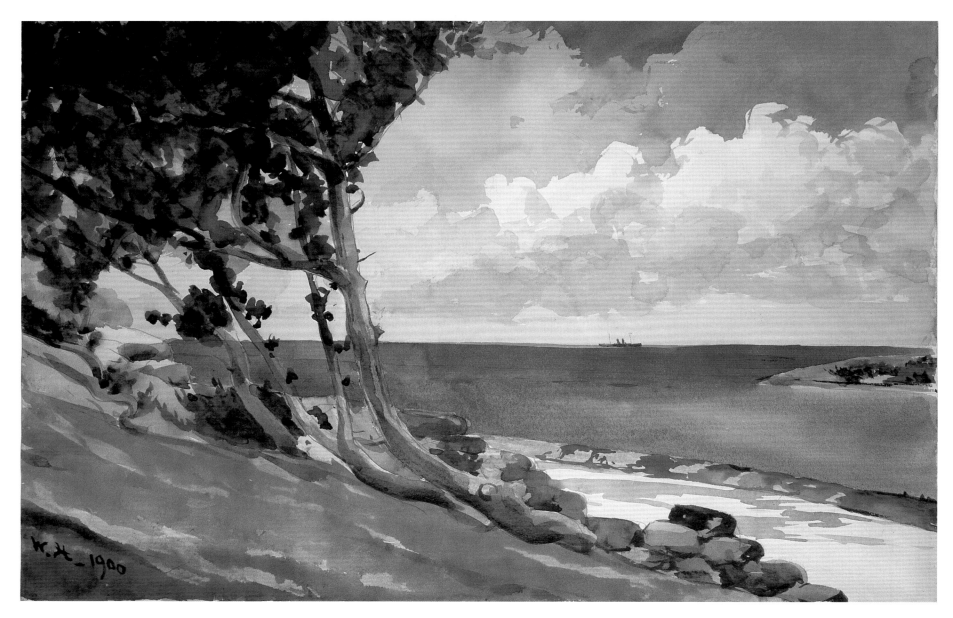

25
Winslow Homer (1836–1910)
North Road, Bermuda, 1900
Watercolor and graphite on white wove paper
13 ¹⁵⁄₁₆ x 21" (35.40 x 53.34 cm)
Partial Gift and Bequest of Bernice McIlhenny
Wintersteen, 1978.19

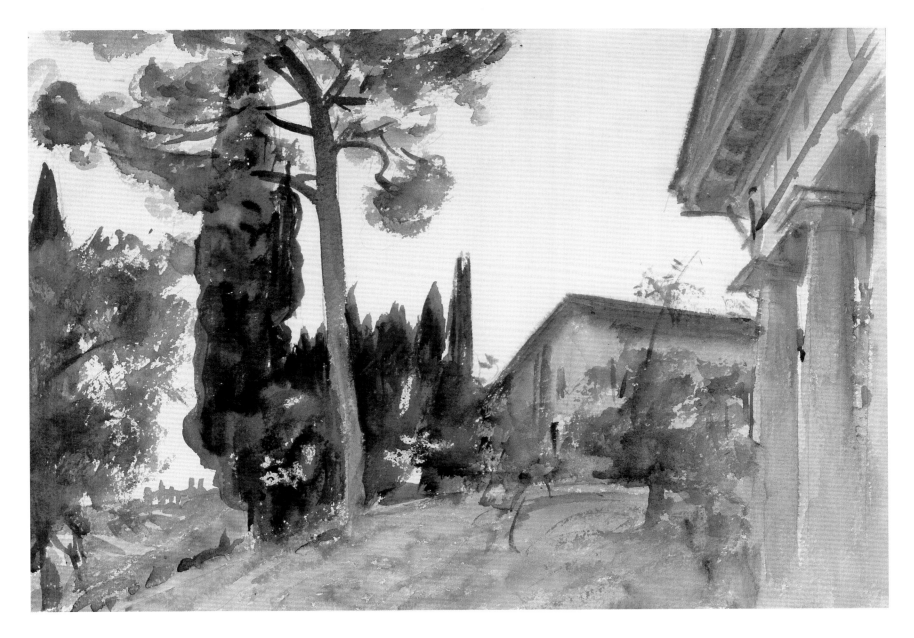

26
John Singer Sargent (1856–1925)
Corfu, 1909
Watercolor over graphite on rough wove paper
13¾ x 19½" (34.93 x 49.53 cm)
Collection of Drs. Meyer P. and Vivian O. Potamkin

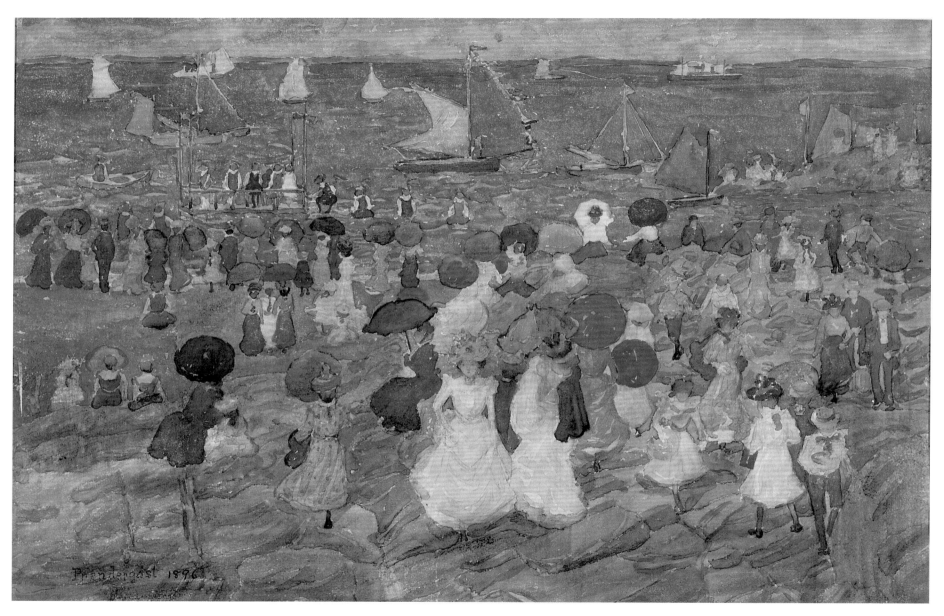

27
Maurice Prendergast (1859–1924)
Nantasket Beach #2 (*Handkerchief Point, Gloucester, Mass.*),
1896
Watercolor over graphite on white wove paper
13¼ x 20¼" (33.66 x 51.44 cm)
Collection of Drs. Meyer P. and Vivian O. Potamkin

28
Marianna Sloan (1875–1954)
Chickens, ca. 1900
Gouache on paperboard
14⅞ x 11⁵⁄₁₆" (37.78 x 28.73 cm)
Gift of William P. Starr, Jr., in
memory of Suzanne A. Starr, 1996.2.1

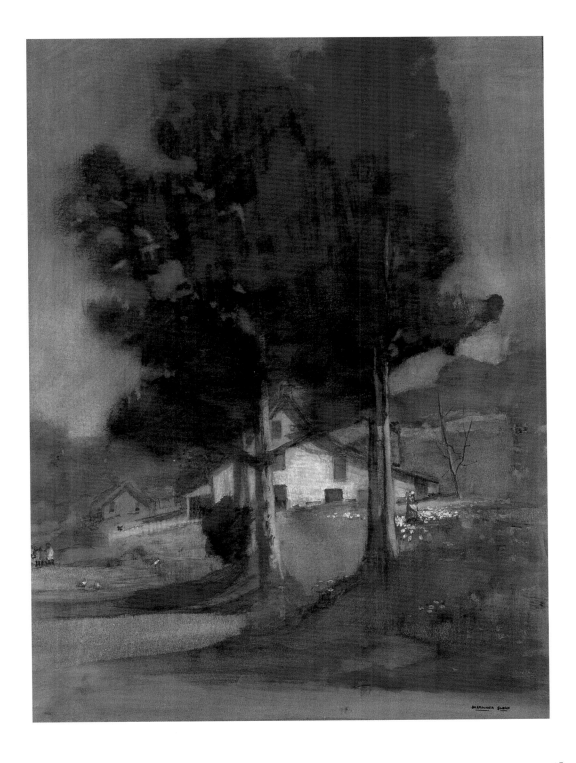

29
Maxfield Parrish (1870–1966)
Old King Cole, 1894
Ink, graphite, watercolor, gouache and
collage on wove paper
13½ x 32" (34.29 x 81.28 cm)
Gilpin Fund Purchase, 1895.4a–c

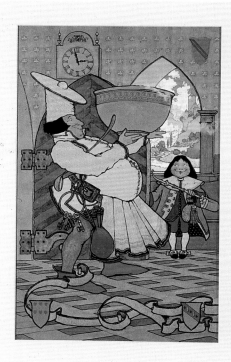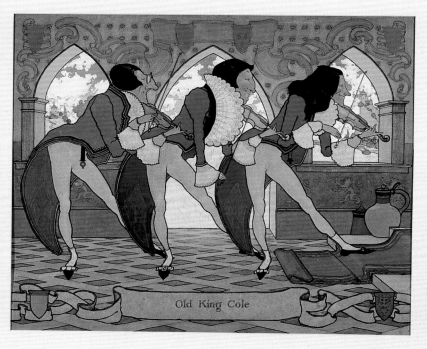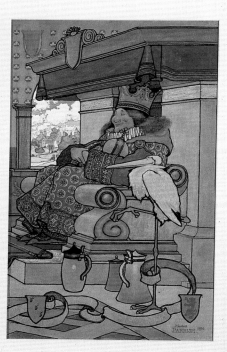

30
Jessie Willcox Smith (1863–1935)
With Thoughtful Eyes, ca. 1909
Watercolor and gouache over charcoal
on illustration board
21⅞ x 15¹⁵⁄₁₆" (55.56 x 40.48 cm)
Gift of the Estate of Jessie Willcox
Smith, 1936.22

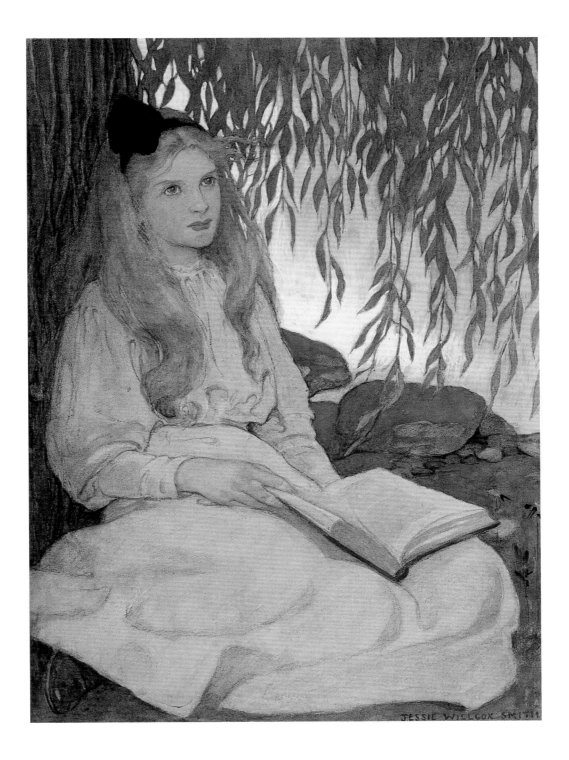

31
Arthur B. Davies (1862–1928)
The Tiger, ca. 1890s
Watercolor and gouache on heavy
wove paper
9⅝ x 14½" (24.45 x 36.83 cm)
Collection of Drs. Meyer P. and
Vivian O. Potamkin

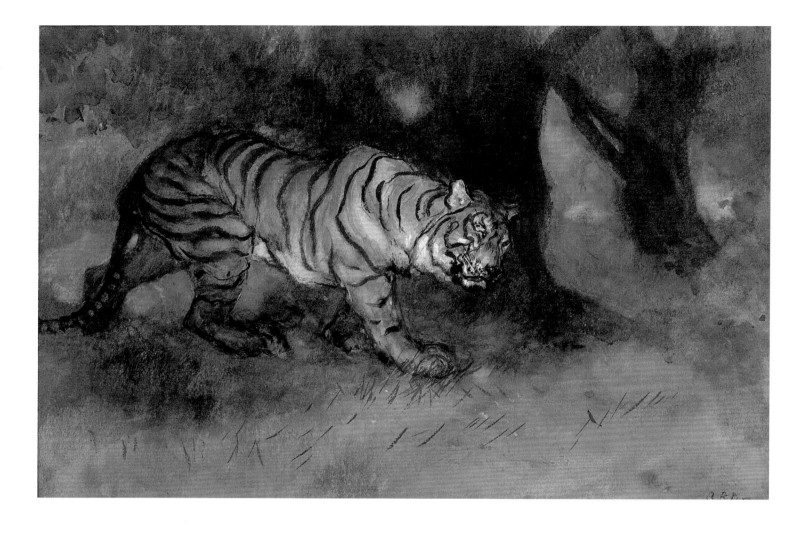

32
Henry McCarter (1864–1942)
Yearly Tribute to the King of Tara, before 1918
Gouache, graphite and chalk on pulpboard
26¹¹⁄₁₆ x 33¼" (67.79 x 84.46 cm)
Gift of Beauveau Borie, 1944.12

48

33
George Walter Dawson (1870–1938)
The Rose and Lily Walk, ca. 1937
Watercolor and graphite on heavy
cream wove paper
22⅝ x 16⅜" (57.47 x 41.59 cm)
Gift of friends of the artist, 1937.17.2

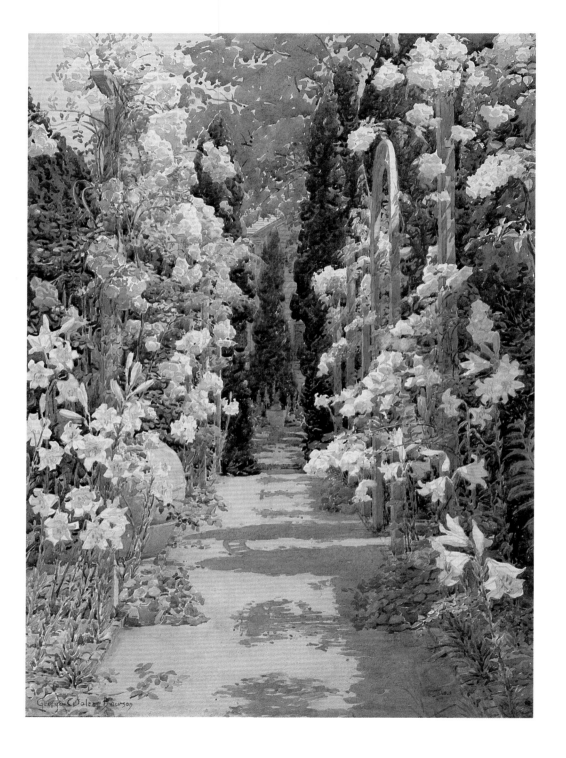

34
George Luks (1867–1933)
Wooded Landscape with Pond, ca. 1925–31
Watercolor on paper
14¾ x 19¾" (37.47 x 50.17 cm)
Gift of Donald and Will Holden in
memory of Rie Yarnall, 1980.23

35
Oscar Bluemner (1867–1938)
Ascension, 1927
Watercolor, gouache and Chinese
white on wove paper mounted
on board
10¼ x 15⁵⁄₁₆" (26.04 x 38.89 cm)
John S. Phillips Fund, 1988.5

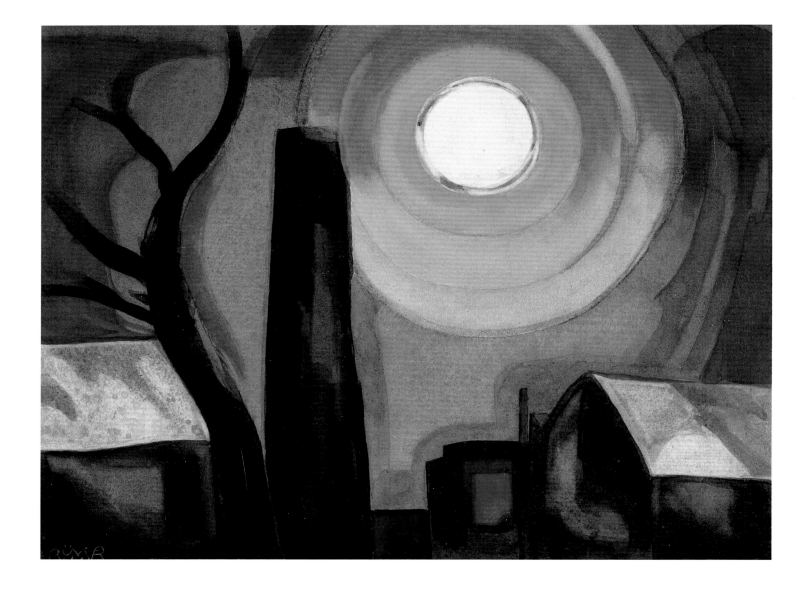

36
John Marin (1870–1953)
Sun, Sea, Land—Maine, 1921
Watercolor and charcoal on off-white
wove paper
16½ x 19½" (41.91 x 49.53 cm)
Acquired from the Philadelphia
Museum of Art (Samuel S. White, 3rd,
and Vera White Collection) in partial
exchange for the John S. Phillips
Collection of European Drawings,
1985.21

37
Arthur G. Dove (1880–1946)
Untitled, ca. 1941–46
Watercolor and gouache on cream
medium-weight paper
3 x 4" (7.62 x 10.16 cm)
Gift of Mr. and Mrs. William Dove,
1985.55.15

38
Charles Demuth (1883–1935)
Box of Tricks, 1919
Gouache and graphite on cardboard
19⅞ x 15⅞" (50.48 x 40.32 cm)
Acquired from the Philadelphia
Museum of Art in partial exchange for
the John S. Phillips Collection of
European Drawings, 1984.8

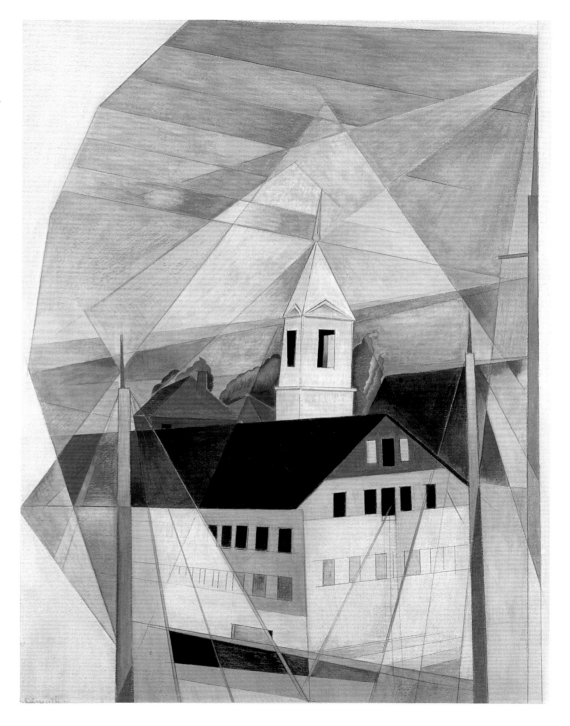

39
Charles Demuth (1883–1935)
Gladiolas, ca. 1923–25
Watercolor and graphite on white
wove watercolor paper
18⅛ x 12" (46.04 x 30.48 cm)
Gift of John Frederick Lewis, Jr.,
1955.7

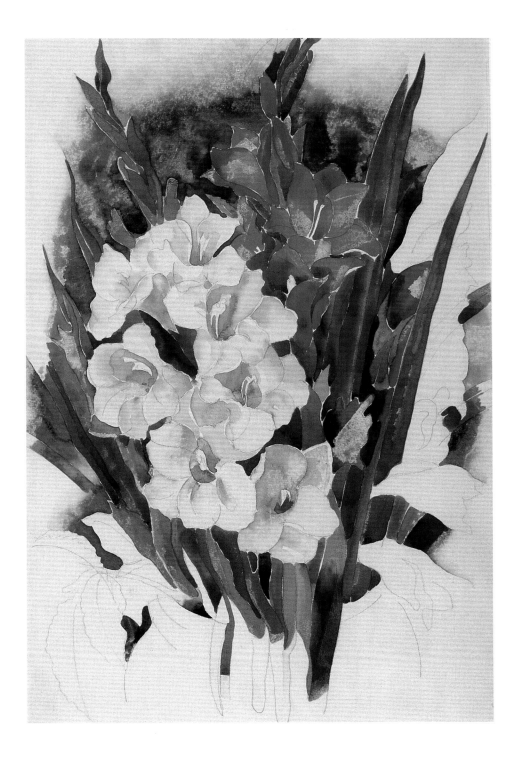

40
Earl Horter (1880–1940)
Toledo, 1924
Gouache on cream watercolor paper
15¼ x 12⅛" (38.74 x 30.8 cm)
Gift of Mrs. Thomas E. Drake, from
the collection of her aunt, Margaretta
Hinchman, 1955.15.6

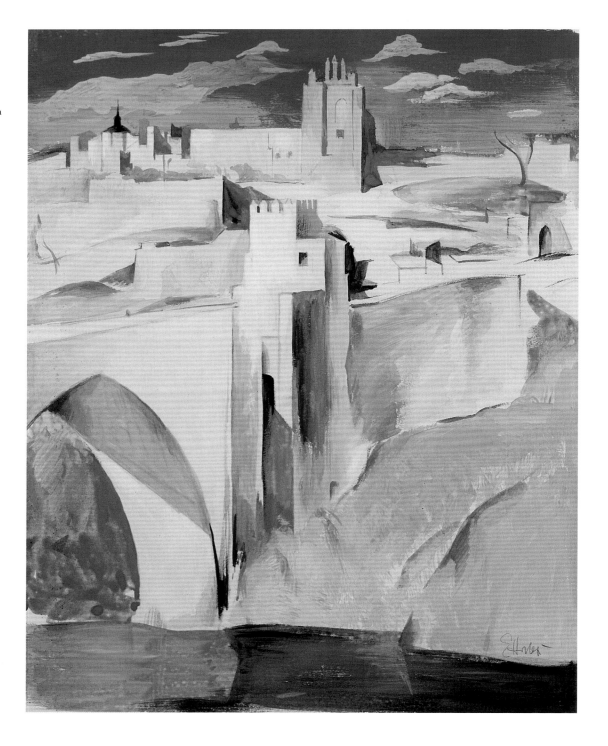

41
Andrew Michael Dasburg (1887–1979)
Along the Tracks, 1934
Watercolor on cream wove paper
22¼ x 15¼" (56.52 x 38.74 cm)
Gift of Miss Gertrude Ely, 1950.19

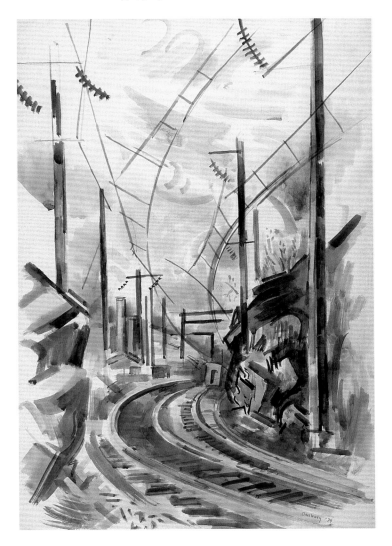

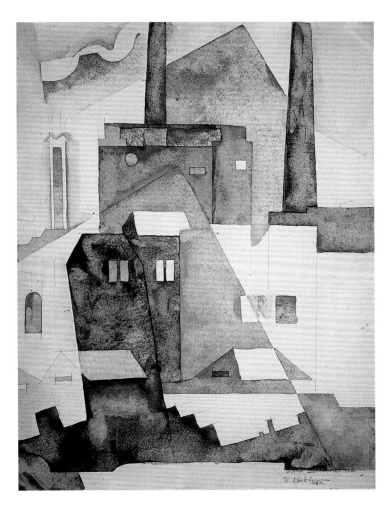

42
Morris Blackburn (1902–1979)
Factory No. 2, 1930
Watercolor and graphite on cream
watercolor paper
14⅝ x 10¹³⁄₁₆" (37.15 x 27.46 cm)
Leo Asbell Fund, 1986.10

43
Arthur B. Carles (1882–1952)
Portrait of Helen, ca. 1920–25
Watercolor on paper
8¾ x 6¼" (22.23 x 15.88 cm)
Collection of Dr. and Mrs. Perry Ottenberg

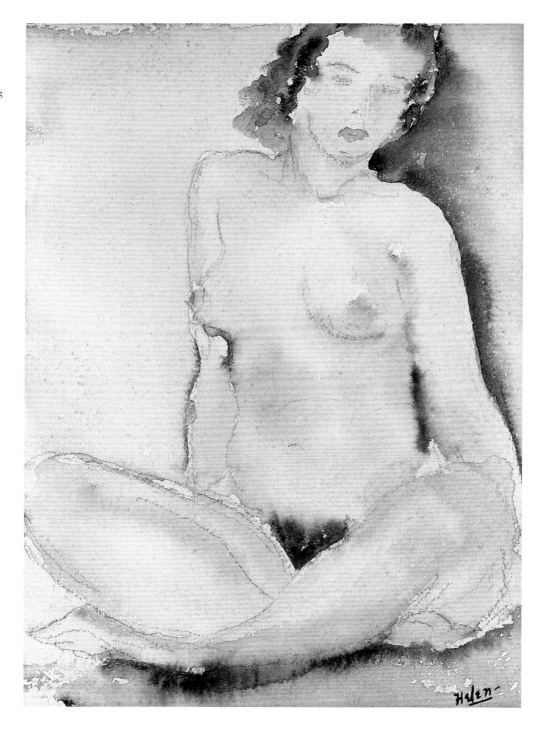

44
Milton Avery (1885–1965)
Artist at Work
Gouache on paper
30 x 20" (76.2 x 50.8 cm)
Makler Family Collection

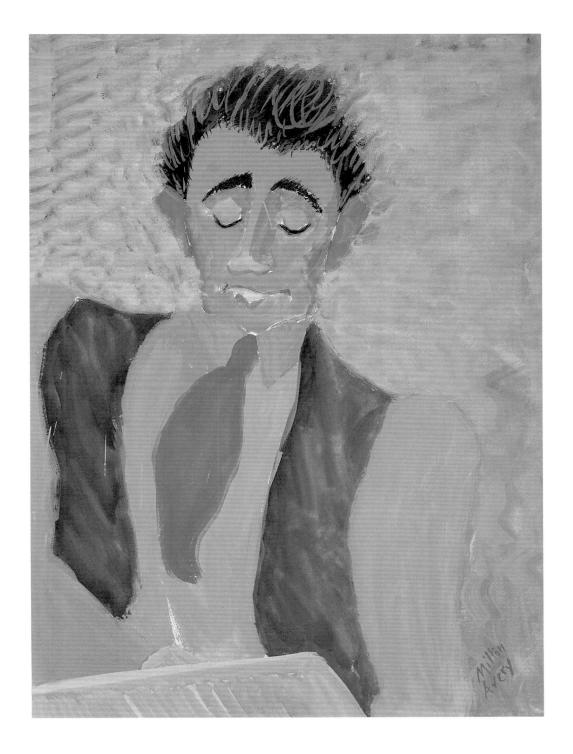

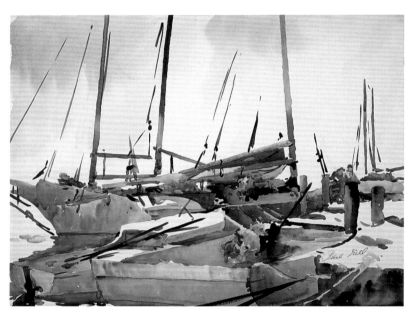

45
Paul Ludwig Gill (1894–1938)
The Lillian, ca. 1927
Watercolor and graphite on composition board
15⅟₁₆ x 21¹¹⁄₁₆" (38.26 x 55.09 cm)
Gift of Mrs. Thomas E. Drake from the collection of her aunt, Margaretta Hinchman, 1955.15.4

46
Reginald Marsh (1898–1954)
Trainyard with Tankcars, 1932
Watercolor and graphite on white watercolor paper
14 x 19¹⁵⁄₁₆" (35.56 x 50.64 cm)
Bequest of Felicia Meyer Marsh, 1979.8.5

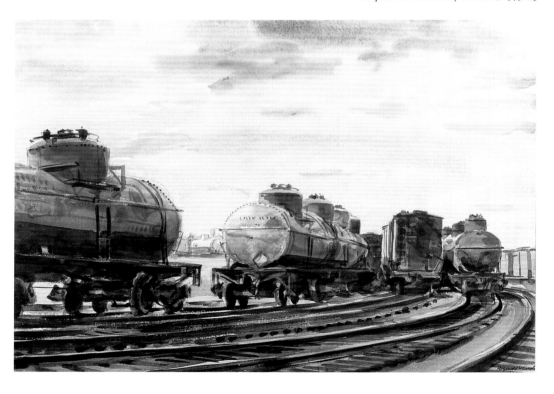

47
Stuart Davis (1894–1964)
Sand Cove, ca. 1931
Gouache on cream wove paper
15 x 19⅝" (38.1 x 49.85 cm)
Gift of Miss Marie Weeks, 1976.8.1

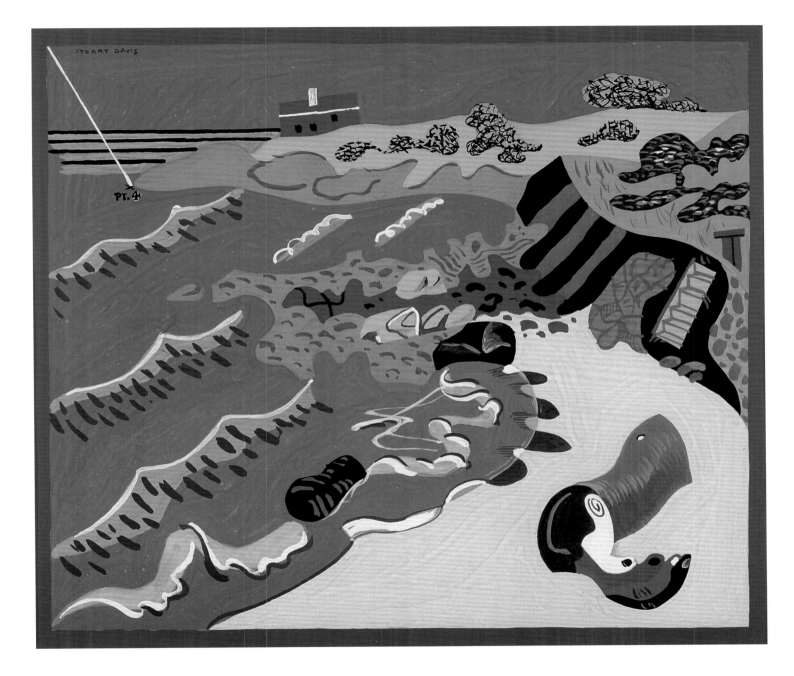

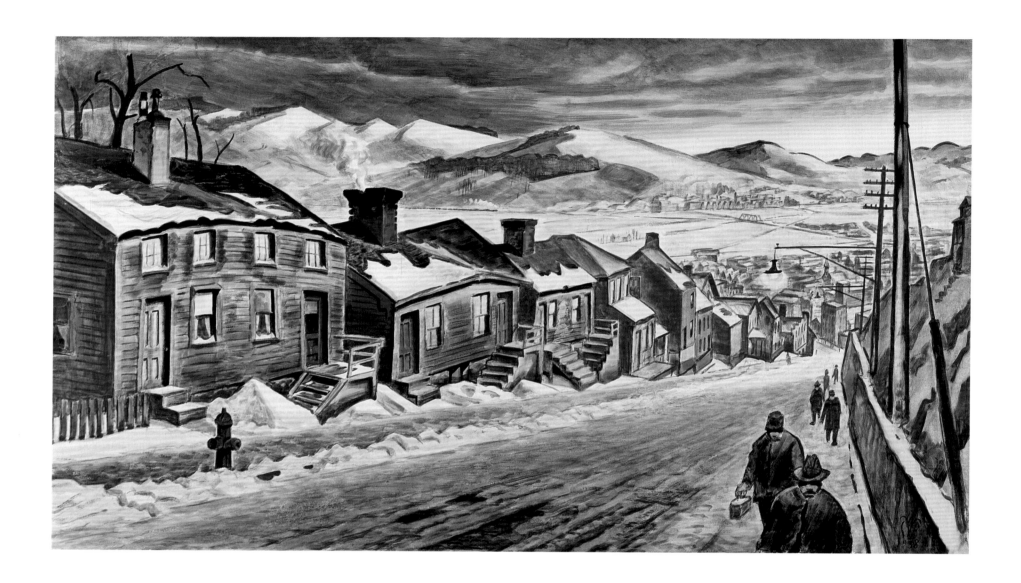

48
Charles E. Burchfield (1893–1967)
End of the Day, 1938
Watercolor over graphite and charcoal
on white paper
28 x 48" (71.12 x 121.92 cm)
Joseph E. Temple Fund, 1940.3

49
Edward Hopper (1882–1967)
House on Dune, South Truro, ca. 1931
Watercolor over graphite on white
wove paper
14 x 20" (35.56 x 50.8 cm)
Collection of Drs. Meyer P. and
Vivian O. Potamkin

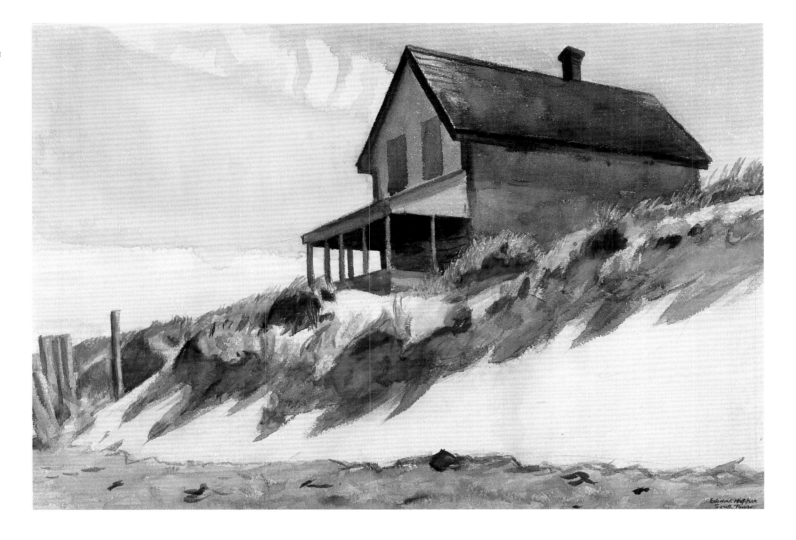

50
Charles E. Burchfield (1893–1967)
Purple Vetch and Buttercups, 1959
Watercolor over charcoal on white
wove paper
39¹³⁄₁₆ x 29¹³⁄₁₆" (101.12 x 75.72 cm)
John Lambert Fund, 1961.1

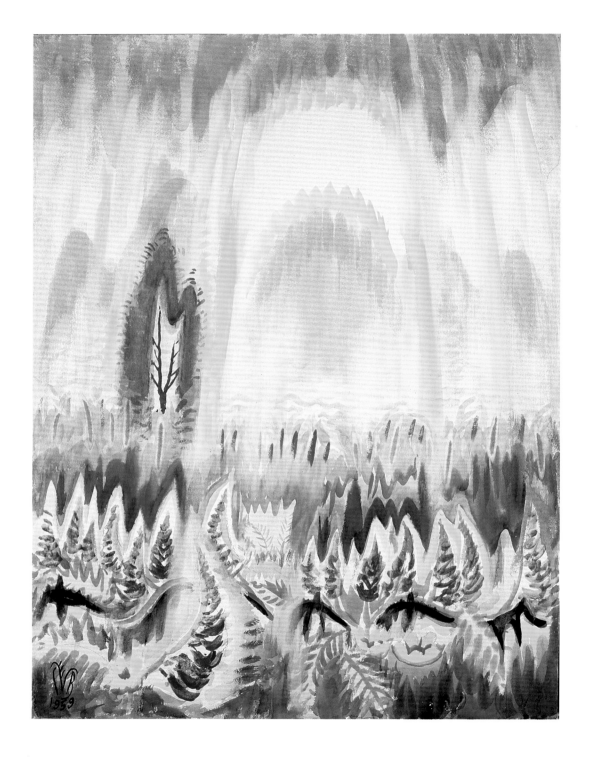

51
Walter Anderson (1903–1965)
Yellow Flowers with Pitcher Plants,
ca. 1940–45
Watercolor and graphite on off-white
watercolor paper
25 x 19" (63.5 x 48.26 cm)
John S. Phillips Fund, 1985.5

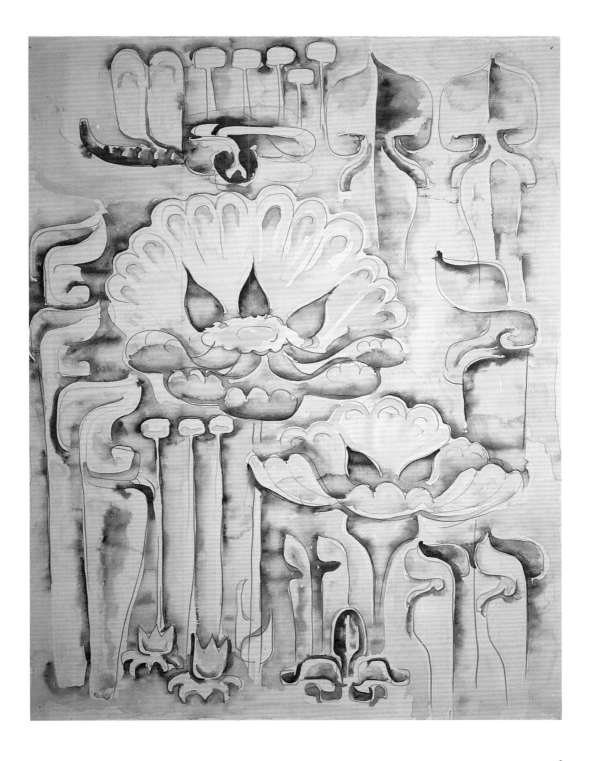

52
Ben Shahn (1898–1969)
Governor James Rolph, Jr., of California,
1932–33
Gouache on board
16 x 12" (40.64 x 30.48 cm)
Collection of Jules and Connie Kay

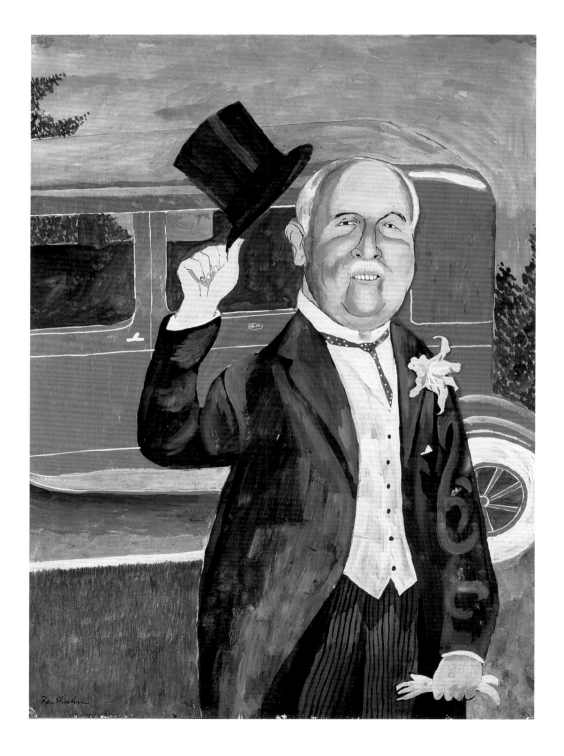

53
George Grosz (1893–1959)
New York Types, 1933
Watercolor on paper
15½ x 10½" (39.37 x 26.67 cm)
Courtesy of CIGNA Museum and
Art Collection

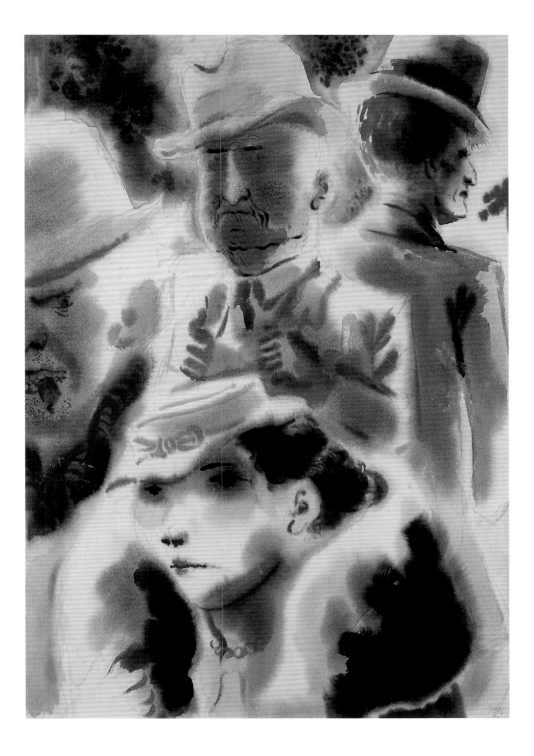

54
Ivan Le Lorraine Albright (1897–1983)
And the Starlight in Her Eyes, ca. 1932
Gouache and watercolor on paper
13¼ x 18" (33.66 x 45.72 cm)
Collection of Jules and Connie Kay

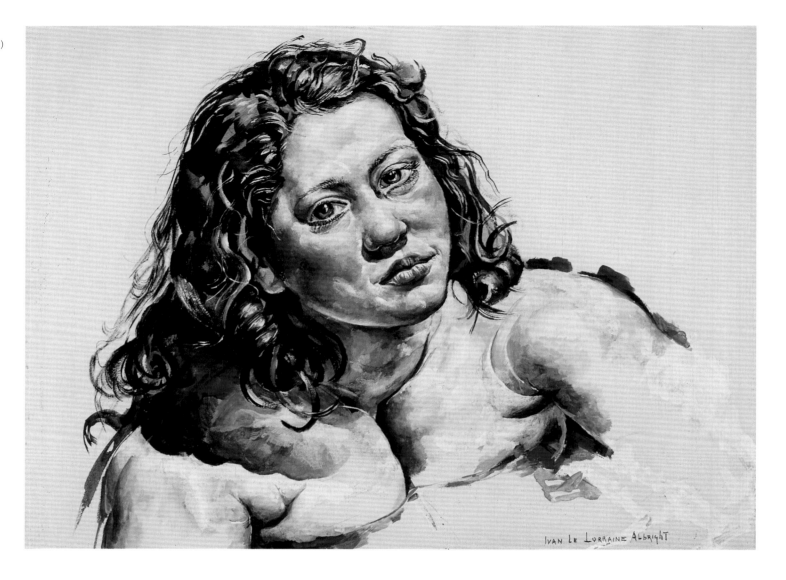

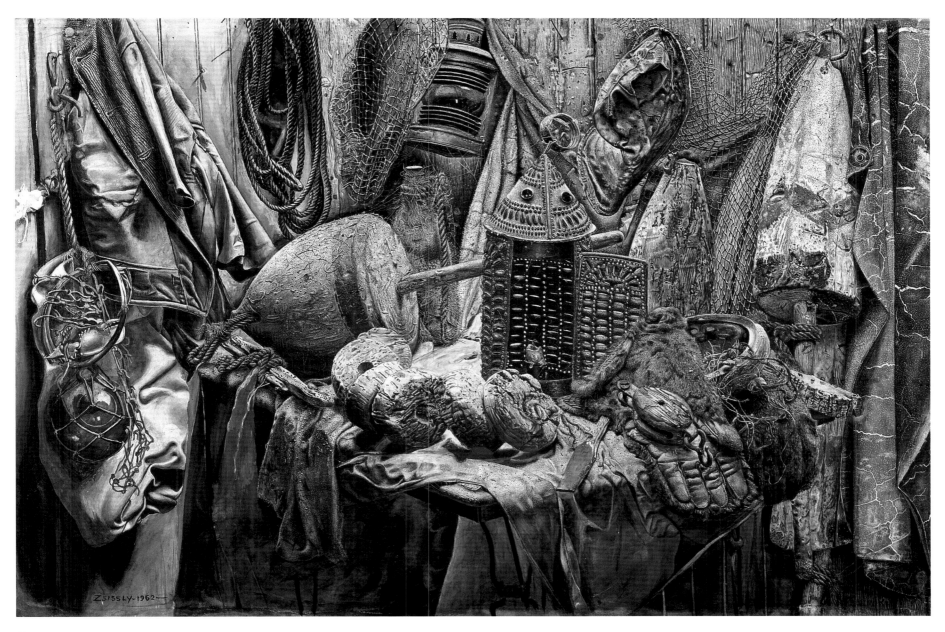

55
Zsissly (Malvin Marr Albright) (1897–1983)
The Trail of Time is Dust, 1962
Watercolor and gouache on paper
27½ x 40½" image (69.85 x 102.87 cm)
Gift of the artist, 1966.12

56
Henry C. Pitz (1895–1976)
After the Show, ca. 1956
Watercolor and gouache on cream
paper mounted to heavy chipboard
27½ x 21¾" (69.85 x 55.25 cm)
John Lambert Fund, 1957.10

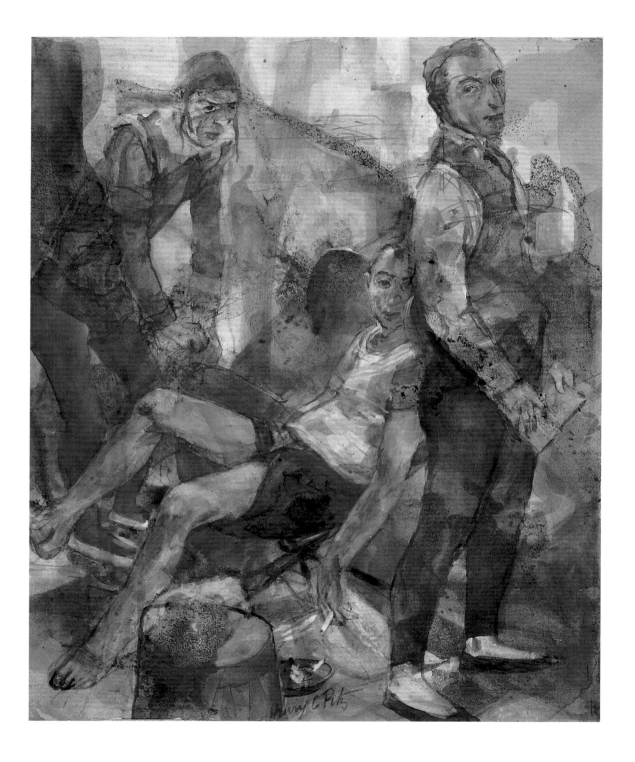

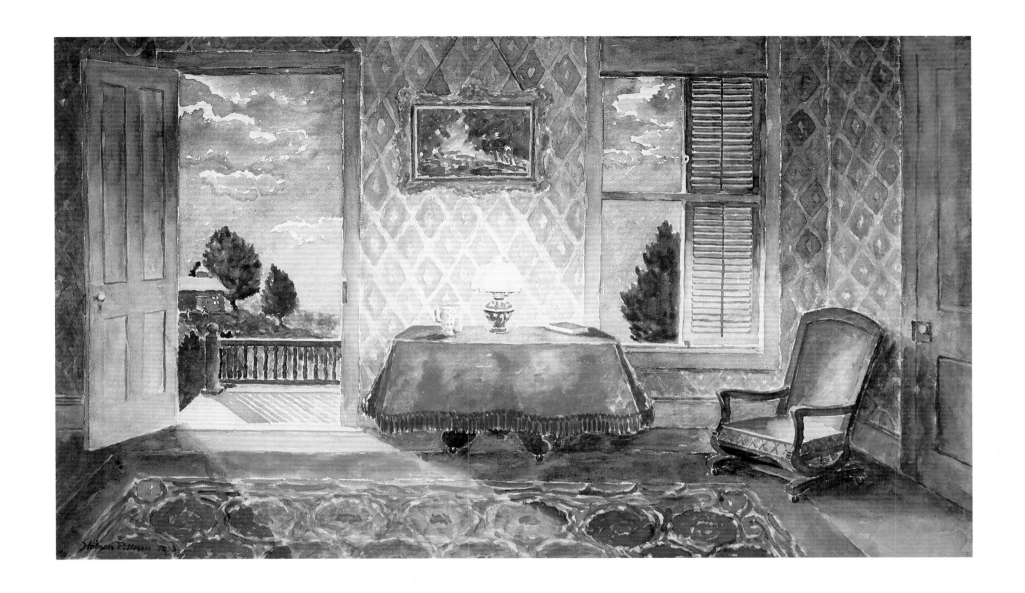

57
Hobson Pittman (1900–1972)
Study for "Summer Evening", 1936
Watercolor over graphite on off-white wove paper
20½ x 34¼" (52.07 x 87 cm)
Bequest of Hobson Pittman, 1972.18.85

58
Alfred Bendiner (1899–1964)
Hotel Monaco and Grand Canal, 1963
Watercolor, pen and ink on white
wove paper
10⁷⁄₁₆ x 18¹⁵⁄₁₆" (26.51 x 48.1 cm)
Gift of Alfred Bendiner, 1973.23.6

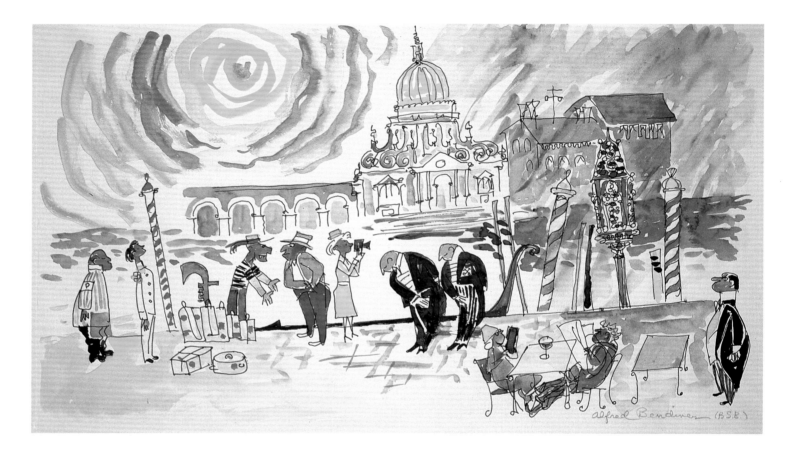

59
Alexander Calder (1898–1976)
Will She Make It?, 1969
Gouache on paper
30 x 43½" (76.2 x 110.49 cm)
Private Collection

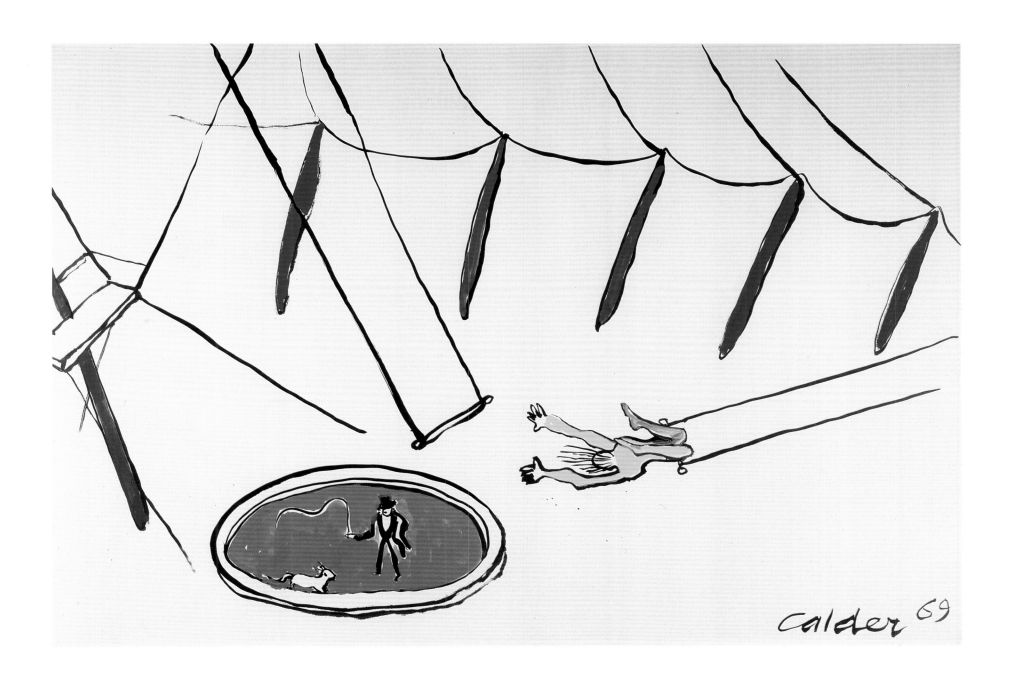

Calder 69

73

60
Hans Hofmann (1880–1966)
Untitled, 1954
Gouache on paper
11 x 14" (27.94 x 35.56)
Private Collection

61
Morris Graves (b. 1910)
Brooding, 1953
Tempera over bronze powder paint over gray wash
19⅞ x 30³⁄₁₆" (25.08 x 76.68 cm)
John Lambert Fund, 1963.1

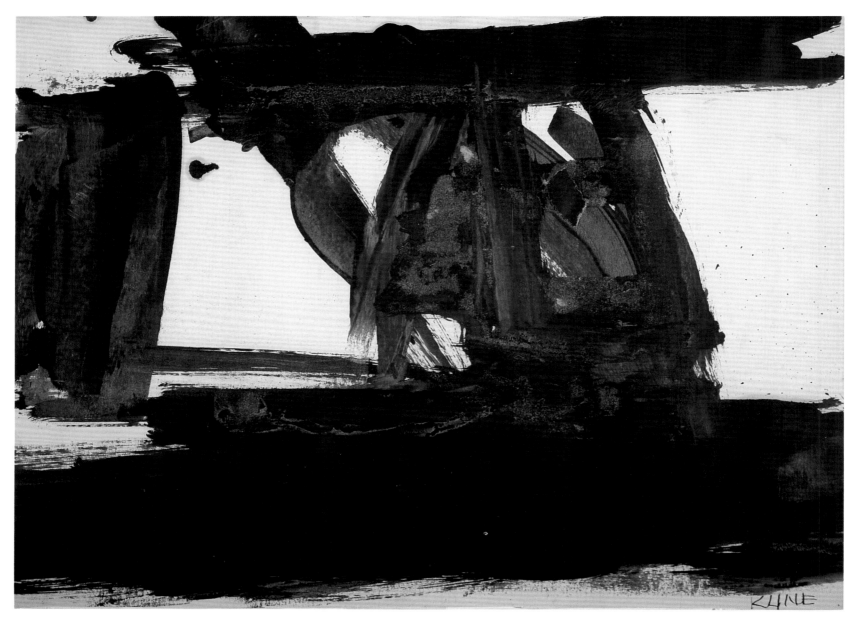

62
Franz Kline (1910–1962)
Untitled, ca. 1953
Oil base black ink wash and collage on cream paper
13⅞ x 18¾" (35.24 x 47.63 cm)
Gift of Gerrish H. Milliken, Jr., 1975.23

63
Robert Motherwell (1915–1991)
Untitled (from "Lyric Suite"), 1965
Ink wash on Japanese paper
11 x 9" (27.94 x 22.86 cm)
Gift of the Dedalus Foundation and
the John Lambert Fund, 1994.6.5.2

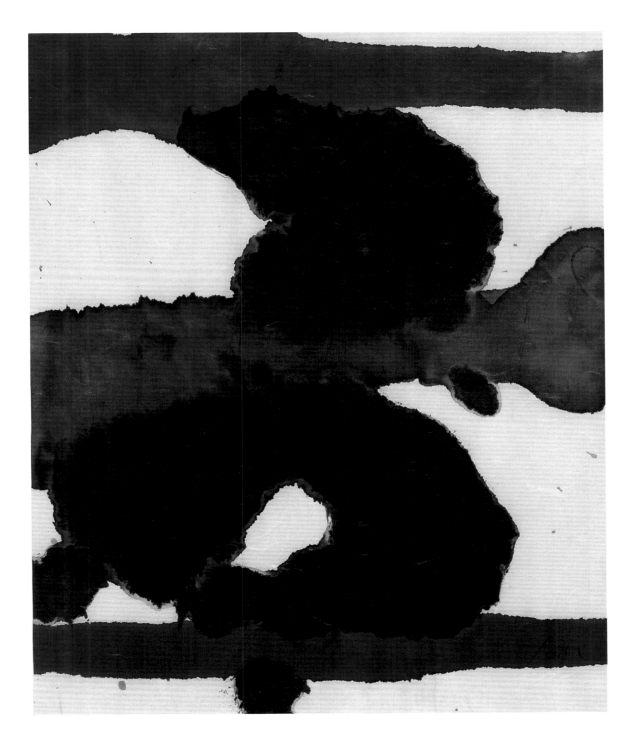

64
Alfred Leslie (b. 1927)
Coal Pile near the Ohio River, 1983
Watercolor on Arches paper
44 x 59" (111.76 x 149.86 cm)
Pennsylvania Academy purchase with
funds provided by the Leo Model
Foundation, 1984.3

65
Philip Pearlstein (b. 1924)
Two Female Models, 1975
Monochrome watercolor on Arches
watercolor paper
29⅞ x 41⅛" (75.88 x 104.46 cm)
Gift of Mr. and Mrs. Al Krakow, 1984.20

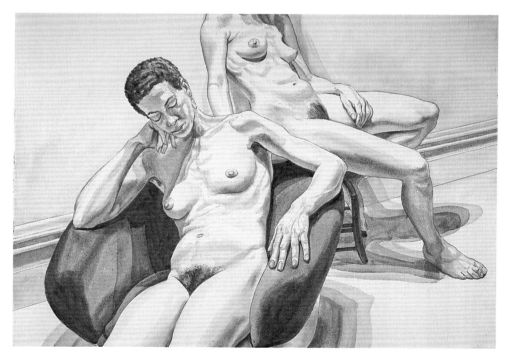

78

66
Andrew Wyeth (b. 1917)
Wet Spring, 1978
Watercolor and gouache on heavy
white wove paper
29 x 22¼" (73.66 x 56.52 cm)
Bequest of Bernice McIlhenny
Wintersteen, 1986.31.1

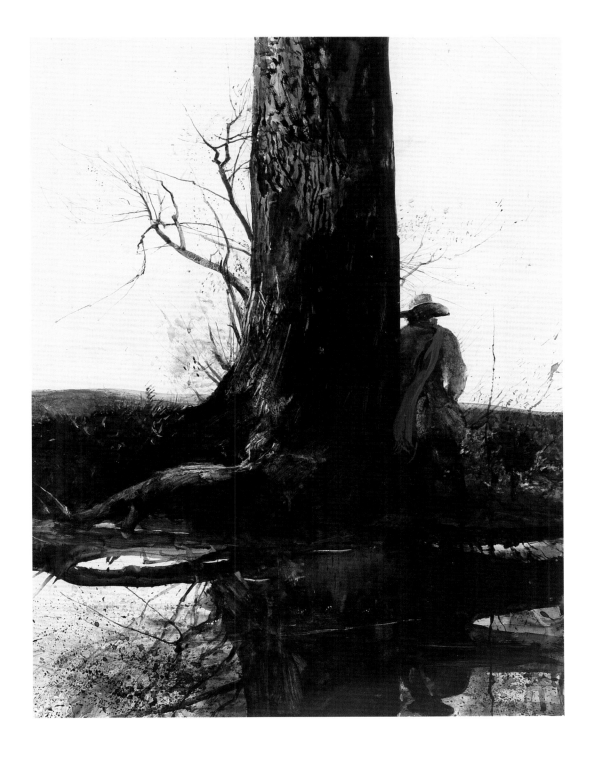

67
Jacob Lawrence (1917–2000)
Images of Labor, 1980
Gouache on paper
25⁷⁄₁₆ x 18¼" image (64.61 x 46.36 cm)
Lent by The Harold A. & Ann R.
Sorgenti Collection of Contemporary
African American Art

68
Willie Birch (b. 1942)
A Farewell Feast..., 1988
Gouache on paper with papier-mâché
frame
44½ x 56½ x 1¾" (113.03 x 143.51
x 4.45 cm)
Lent by The Harold A. & Ann R.
Sorgenti Collection of Contemporary
African American Art

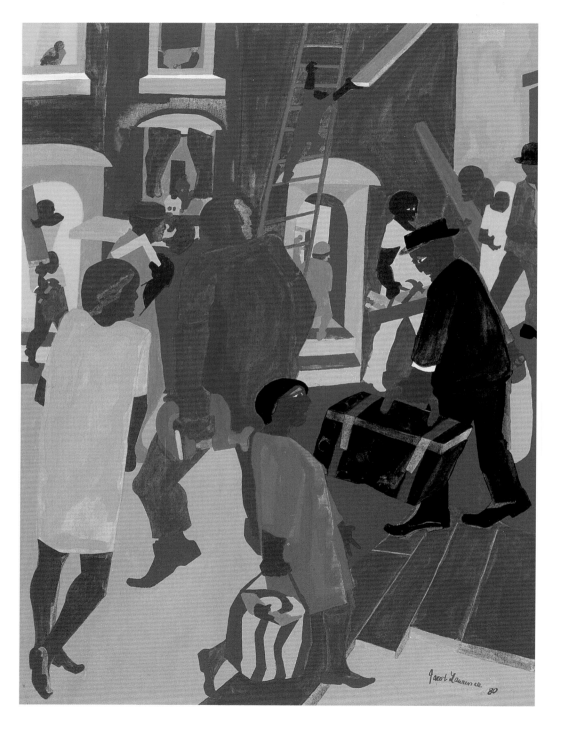

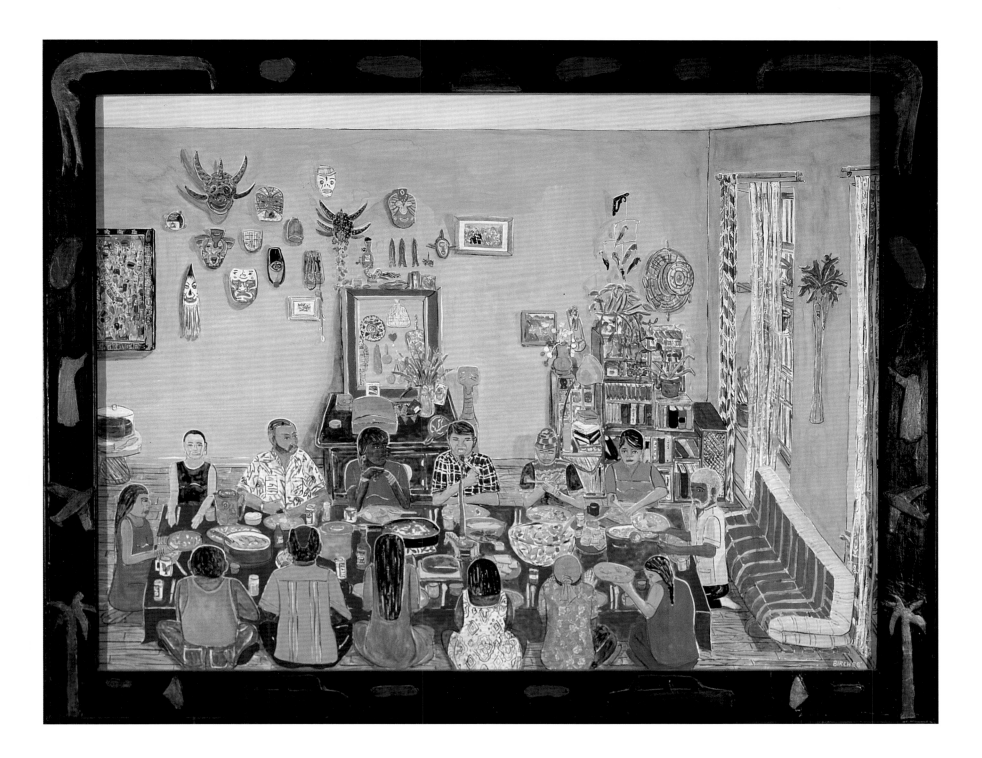

69
Joseph Raffael (b. 1933)
Water with Fish, 1985
Watercolor on heavy paper
28¾ x 38½" (73.03 x 97.79 cm)
John S. Phillips Fund, 1985.11

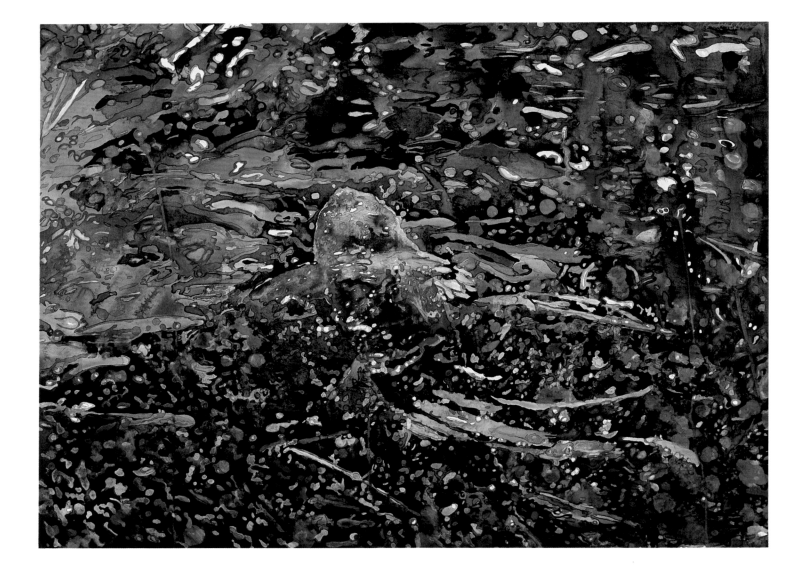

70
Elizabeth Osborne (b. 1936)
Rookwood Still Life, 1980
Watercolor on Arches paper
29¾ x 39½" (75.57 x 100.33 cm)
Anonymous gift, 1986.34

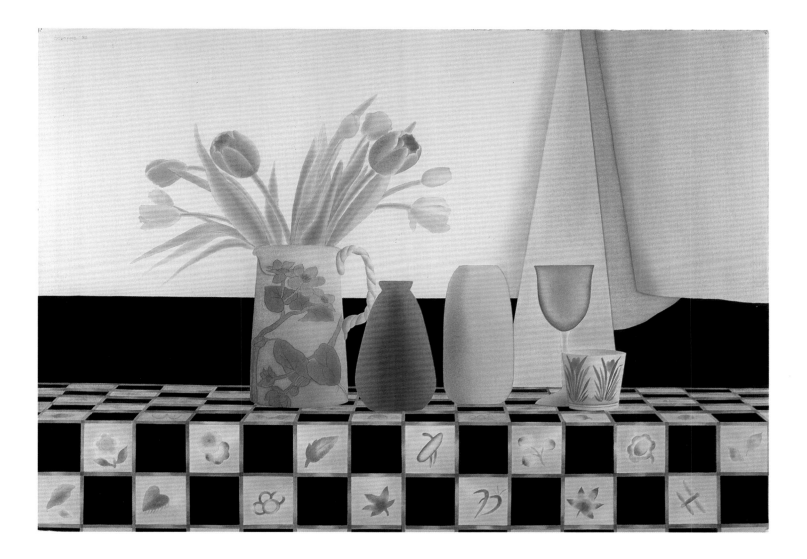

71
Mary Frank (b. 1933)
Untitled #9, 1975
Watercolor and ink on ivory
wove paper
20⅝ x 26¹³⁄₁₆" (52.39 x 68.10 cm)
Gift of Jalane & Richard Davidson
1986.25

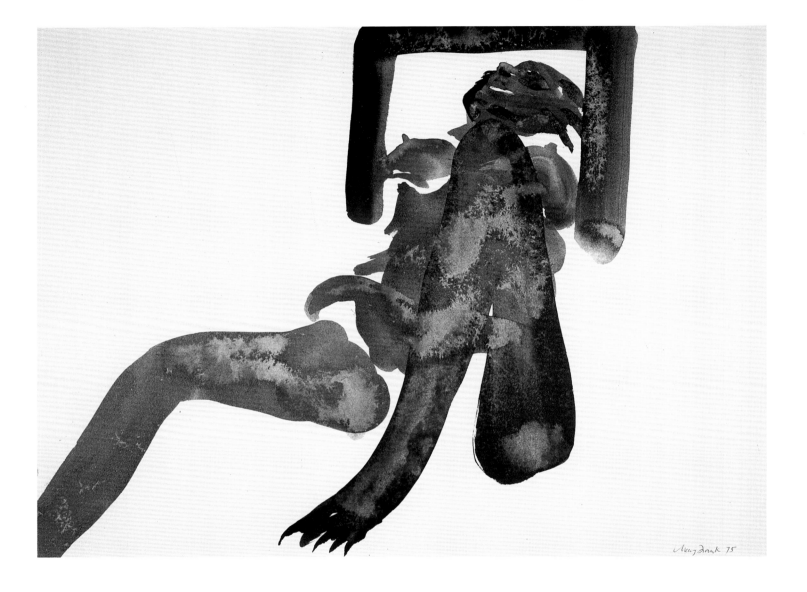

84

72
Raymond Saunders (b. 1934)
Untitled, 1991
Gouache, watercolor, ink, colored
pencil, graphite, metallic paint, acrylic
paint, cellophane tape, wooden sticks, a
paintbrush and a pencil on paper collage
49⅞ x 38⅛" (126.68 x 96.84 cm)
Lent by The Harold A. & Ann R.
Sorgenti Collection of Contemporary
African American Art

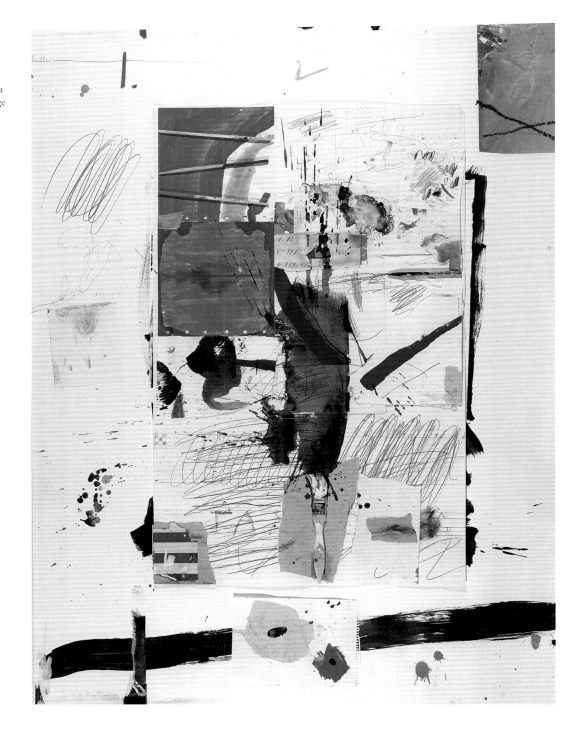

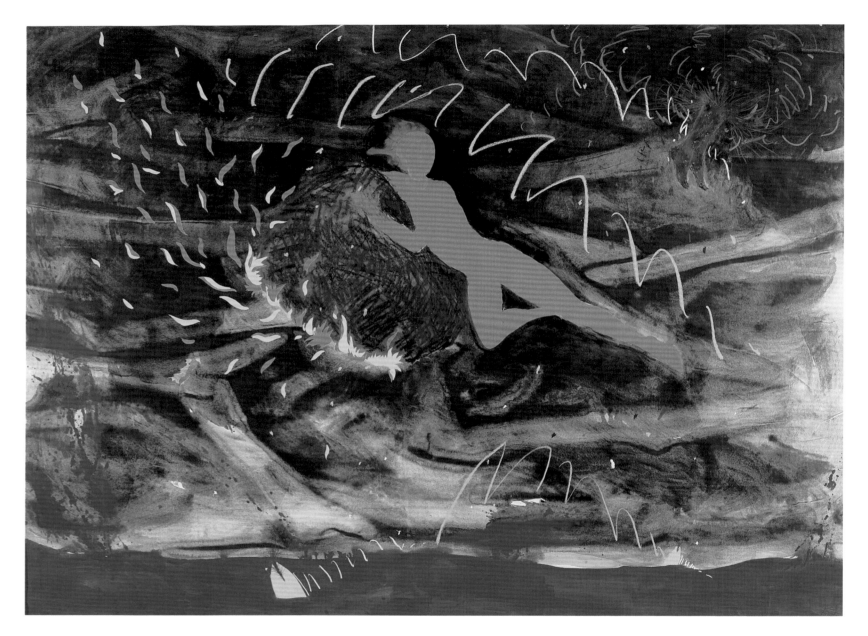

73
Jody Pinto (b. 1942)
Henri with a Soft Meteor, 1983
Watercolor, gouache, grease crayon and graphite on rag paper
70 x 93½" (177.8 x 237.49 cm)
John S. Phillips Fund and exchange Courtesy of Gene Locks, 1985.6

74
Gladys Nilsson (b. 1940)
Pussy and Herbert: Their Second Date,
1969
Watercolor over graphite on heavy
white wove paper
22⅜ x 15¼" (56.83 x 38.74 cm)
Gift of Marion Stroud Swingle,
1986.16

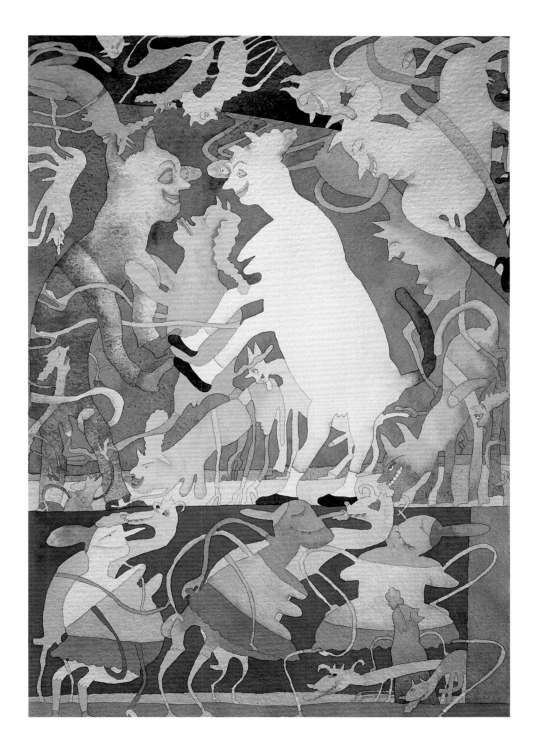

75
John E. Dowell, Jr. (b. 1941)
The Myth of Being, 1990 (left)
Watercolor and ink on two sheets of
heavy white wove paper
60 x 11¼" (152.4 x 28.58 cm)
Lent by The Harold A. & Ann R.
Sorgenti Collection of Contemporary
African American Art

76
John E. Dowell, Jr. (b. 1941)
Del Mar, 1990 (right)
Watercolor and ink on two sheets of
heavy white wove paper
60⅛ x 11¼" (152.72 x 28.58 cm)
Lent by The Harold A. & Ann R.
Sorgenti Collection of Contemporary
African American Art

77
Robert Stackhouse (b. 1942)
Deep Swimmers and Mountain Climbers,
1985
Charcoal, graphite, watercolor and
Chinese white on cream wove paper
89½ x 119¹⁵⁄₁₆" (227.33 x 304.64 cm)
John S. Phillips Fund, 1987.9

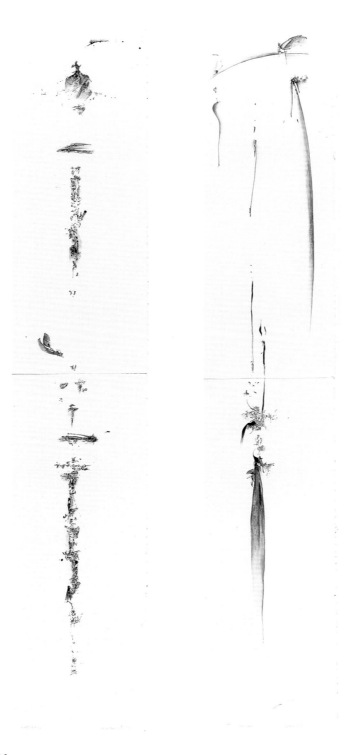

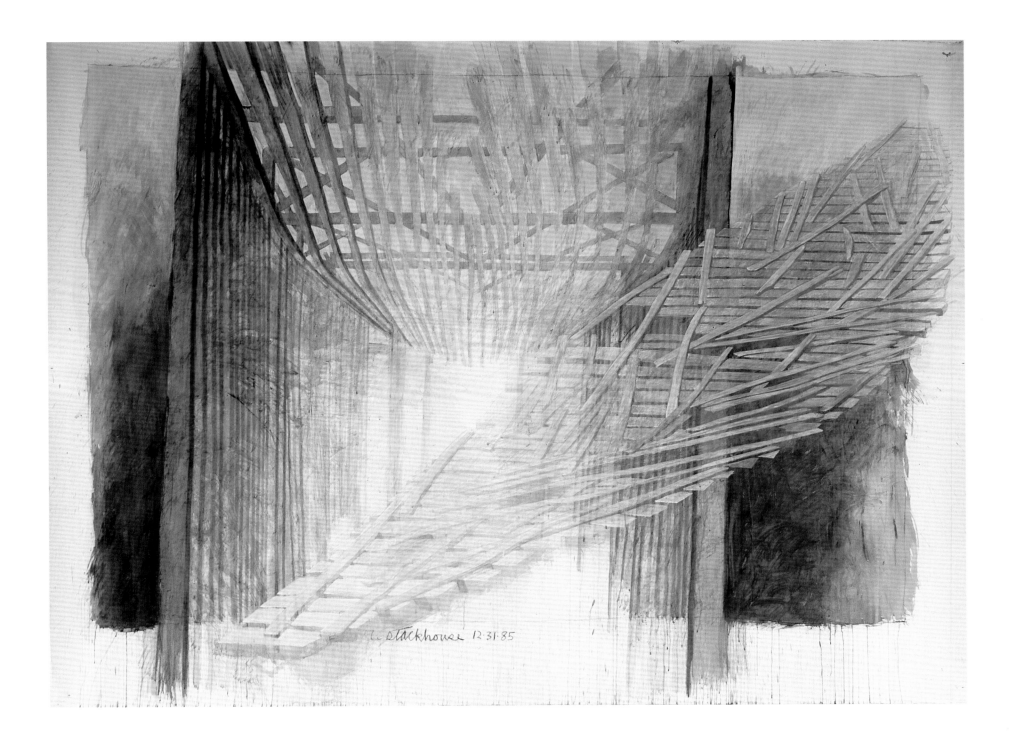

R. Stackhouse 12·31·85

79
Sam Gilliam (b. 1933)
Another Rose, 1999
Acrylic and acrylic media on
stitched and folded polypropylene
(watercolor processes)
11 x 13⅜ x 3⁵⁄₁₆" (27.94 x 33.97
x 8.41 cm)
Lent by the artist

Exhibition Checklist

All works are from the collection of the Pennsylvania Academy of the Fine Arts unless otherwise noted. All dimensions are given with height preceding width and refer to sheet size unless otherwise noted.

Eighteenth and Nineteenth Centuries

Edwin Austin Abbey (1852–1911)
The Eve of Saint Agnes, 1879
Ink wash and Chinese white on cream
 wove paper
17⅜ x 9³⁄₁₆" (44.13 x 23.34 cm)
John S. Phillips Fund, 1988.9

Thomas Anshutz (1851–1912)
Untitled, ca. 1900–10
Watercolor on cardboard
9¹⁵⁄₁₆ x 7¹⁵⁄₁₆" (25.24 x 20.16 cm)
Gift of Mrs. Edward Anshutz, 1971.8.68

Thomas Anshutz (1851–1912)
Untitled, ca. 1890
Watercolor on cream watercolor paper
27⅞ x 15" (70.80 x 38.1 cm)
Gift of Mrs. Edward Anshutz, 1971.8.69

Cecilia Beaux (1855–1942)
Portrait of Edmund James Drifton Coxe,
 1884
Watercolor on heavy wove paper
24⅛ x 18¼" (61.29 x 46.36 cm)
Gift of Maria M. Skinner, 1992.6

Attributed to William Birch (1755–1834)
Figures in a Garden, ca. 1805
Watercolor, pen and brown ink on
 cream paper
6¹⁄₁₆ x 6¹⁄₁₆" (15.4 x 15.4 cm)
Collections Fund Purchase, 1962.20.2

Robert F. Blum (1857–1903)
Old Powhatan Chimney, 1879–80
Watercolor, Chinese white and
 graphite on cream watercolor paper
9⅛ x 7½" (23.18 x 19.05 cm)
Gift of Mrs. James Mapes Dodge,
1951.30.1

Fidelia Bridges (1834–1923)
Grass and Poison Ivy, ca. 1880
Gouache and watercolor on off-white
 wove paper
13¹⁵⁄₁₆ x 10" (35.40 x 25.4 cm)
Henry D. Gilpin Fund, 1983.1

William H. Crane (dates unknown)
Evans and Hoey, ca. 1885
Gouache, watercolor and graphite on
 gray-green wove paper
14¼ x 19¼" (36.2 x 48.9 cm)
Gift of Mr. Wells M. Sawyer (1945),
 1984.x.10

Charles Edmund Dana (1843–1914)
School at Fribourg, 1890
Watercolor over graphite on off-white
 wove paper
21⅛ x 14⁹⁄₁₆" (53.66 x 36.99 cm)
Gift of the artist, 1915.1.2

Arthur B. Davies (1862–1928)
The Tiger, ca. 1890s
Watercolor and gouache on heavy wove
 paper
9⅝ x 14½" (24.45 x 36.83 cm)
Collection of Drs. Meyer P. and Vivian
 O. Potamkin

Attributed to Mary Douglass
 (dates unknown)
Acorns and Oak Leaves, 1839
Watercolor, graphite and ink on cream
 wove paper
7⁷⁄₁₆ x 6" (18.9 x 15.24 cm)
Sales Desk Development Fund
 Purchase, 1969.25.1

Attributed to Mary Douglass
 (dates unknown)
Blue Flowers, Leaves, and Dove, 1839
Watercolor and ink on cream wove paper
7⁷⁄₁₆ x 6" (18.9 x 15.24 cm)
Sales Desk Development Fund Purchase,
 1969.25.2

Attributed to Mary Douglass
 (dates unknown)
Blue Flowers, Leaves, Lyre, Pipe, and Music,
 1839
Watercolor and ink on cream wove paper
7⁷⁄₁₆ x 6" (18.9 x 15.24 cm)
Sales Desk Development Fund Purchase,
 1969.25.3

Attributed to Mary Douglass
 (dates unknown)
Pansies, 1839
Watercolor and ink on cream wove paper
7⁷⁄₁₆ x 6" (18.9 x 15.24 cm)
Sales Desk Development Fund Purchase,
 1969.25.4

Attributed to Mary Douglass
 (dates unknown)
Wild Rose, 1839
Watercolor, graphite and ink on off-white
 wove paper
7⁷⁄₁₆ x 5¹⁵⁄₁₆" (18.9 x 15.08 cm)
Sales Desk Development Fund Purchase,
 1969.25.5

Thomas Eakins (1844–1916)
Sketch for Retrospection, ca. 1880
Watercolor on paper
15 x 11" (38.1 x 27.94 cm)
Philadelphia Museum of Art, Gift of Mrs.
 Thomas Eakins and Miss Mary A.
 Williams, 1930-32-2

Seth Eastman (1808–1875)
Indians in Camp, 1848
Watercolor and graphite on off-white
 paper
8¼ x 7¹⁄₁₆" (20.96 x 17.94 cm)
1982.x.17

Charles Lewis Fussell (1840–1909)
Boy on a Tree Branch, 1897
Watercolor and gouache on cream paper
7⁵⁄₁₆ x 5¼" (18.57 x 13.34 cm)
Gift of the T. Carrick Jordan Fund
 through Bertram L. O'Neill, Henry S.
 McNeil and Mrs. Edward B. Leisenring,
 Jr., 1973.12.62

Charles Lewis Fussell (1840–1909)
Self Portrait in Landscape, ca. 1900
Watercolor on wove paper
9 x 12" (22.86 x 30.48 cm)
Gift of the T. Carrick Jordan Fund
 through Bertram L. O'Neill, Henry
 S. McNeil and Mrs. Edward B.
 Leisenring, Jr., 1973.12.83

Charles Lewis Fussell (1840–1909)
Young Girl at Forest Spring, 1903
Watercolor and gouache on cream
 wove paper
14 x 23⅞" (35.56 x 60.64 cm)
Gift of Mrs. Henry M. Fussell, 1974.8

Josiah Green (dates unknown)
Woman on Swing, 1859
Ink, ink wash and gouache on blue-
 green wove paper
6⅝ x 5⁷⁄₁₆" (16.83 x 13.81 cm)
Gift of Saul and Ellen Lapp, 1984.24.2

Charles Paul Gruppe (1860–1940)
Landscape: Holland, ca. 1895–1900
Watercolor, gouache and charcoal on
 heavy wove paper
13⅝ x 24¹³⁄₁₆" (34.61 x 63.02 cm)
Gift of the Misses Cope, 1904.5

Philip B. Hahs (1853–1882)
Old Recollections, 1882
Watercolor on off-white wove paper
14⁷⁄₁₆ x 10⅜" (36.67 x 26.35 cm)
Gift of Mrs. Charles B. Hahs, 1884.2.1

Winslow Homer (1836–1910)
North Road, Bermuda, 1900
Watercolor and graphite on white
 wove paper
13¹⁵⁄₁₆ x 21" (35.40 x 53.34 cm)
Partial Gift and Bequest of Bernice
 McIlhenny Wintersteen, 1978.19

Winslow Homer (1836–1910)
Waiting, 1880
Watercolor on paper
8½ x 12½" (21.59 x 31.75 cm)
Courtesy of CIGNA Museum and Art
 Collection

Edward Greene Malbone (1777–1807)
Asher Marx, 1803
Watercolor on ivory
2¾ x 2⅛" (6.99 x 5.4 cm)
Gift of Frank Marx Etting, 1886.1.1

Edward Greene Malbone (1777–1807)
Joseph Marx, 1806
Watercolor on ivory
3 x 2⅜" (7.62 x 6.03 cm)
Gift of Frank Marx Etting, 1886.1.2

Hugh Newell (1830–1915)
Seated Girl Reading, 1878
Watercolor on cream wove paper
15¼ x 22⁵⁄₁₆" (38.74 x 56.67 cm)
Henry D. Gilpin Fund, 1973.11

Anna Claypoole Peale (1791–1878)
Madame Lallemand, ca. 1810
Watercolor on ivory
1⅞ x 1½" (4.76 x 3.81 cm)
Gift of Charles Hare Hutchinson, 1898.10

James Peale (1749–1831)
Eliza Anthony Smith, ca. 1805–10
Watercolor over graphite on buff wove
 paper
5 x 4³⁄₁₆" (12.7 x 10.64 cm)
Collections Fund Purchase, 1966.8.1

James Peale (1749–1831)
Frances Gratz Etting, 1794
Watercolor on ivory
2⅜ x 1⁹⁄₁₆" (6.03 x 3.97 cm)
Gift of Frank Marx Etting, 1886.1.4

James Peale (1749–1831)
Reuben Etting, 1794
Watercolor on ivory
2⁷⁄₁₆ x 1¹³⁄₁₆" (6.19 x 4.6 cm)
Gift of Frank Marx Etting, 1886.1.5

James Peale (1749–1831)
William Rudolph Smith, ca. 1805–10
Ink wash over graphite on buff wove
 paper
4¼ x 3¾" (10.8 x 9.53 cm)
Collections Fund Purchase, 1966.8.2

Maurice Prendergast (1859–1924)
Montparnasse (Paris), ca. 1907–10
Watercolor over black pastel and chalk on thick white watercolor paper
14⅜ x 20½" (36.51 x 52.07 cm)
Collection of Drs. Meyer P. and Vivian O. Potamkin

Maurice Prendergast (1859–1924)
Nantasket Beach #2 (Handkerchief Point, Gloucester, Mass.), 1896
Watercolor over graphite on white wove paper
13¼ x 20¼" (33.66 x 51.44 cm)
Collection of Drs. Meyer P. and Vivian O. Potamkin

William Trost Richards (1833–1905)
Cornish Coast, ca. 1880–90
Watercolor and gouache on tan wove paper
8⁷⁄₁₆ x 14¼" (21.43 x 36.2 cm)
Bequest of Mrs. William T. Brewster through the National Academy of Design, 1954.2.4

William Trost Richards (1833–1905)
Hills and Sea: Newport Landscape, ca. 1875
Watercolor and gouache on off-white wove paper
9 x 14⁷⁄₁₆" (22.86 x 36.67 cm)
Bequest of Mrs. William T. Brewster through the National Academy of Design, 1954.2.13

William Trost Richards (1833–1905)
Rocks and Sea, 1874
Watercolor on gray Bristol board
8½ x 13¹⁵⁄₁₆" (21.59 x 35.4 cm)
Gift of Mr. and Mrs. H. Lea Hudson in memory of Mr. and Mrs. George Farnam Brown, 1973.17.2

Peter Frederick Rothermel (1817–1895)
Figure Studies after Veronese, 1857–58
Watercolor and graphite on cream wove paper
12⅛ x 8¹³⁄₁₆" (30.8 x 22.38 cm)
Gift of Saul and Ellen Lapp, 1984.24.28

Peter Frederick Rothermel (1817–1895)
Roman Baths in Paris, 1856
Watercolor, Chinese white and graphite on cream wove paper
8⅞ x 5⅝" (22.54 x 14.29 cm)
Gift of Saul and Ellen Lapp, 1983.20.2

John Sartain (1808–1897)
Portrait of a Man, 1826
Watercolor on wove paper
8⅞ x 7" image (22.54 x 17.9 cm)
Bequest of Dr. Paul J. Sartain, 1948.23.1427

Christian Schussele (1824–1879)
Queen Esther Sues for Her Own Life and the Lives of Her Subjects, 1866
Watercolor over graphite on gray wove paper
10⁷⁄₁₆ x 18⅝" (26.51 x 47.31 cm)
Leo Asbell Fund, 1973.1

Henry Colton Shumway (1807–1884)
Mrs. John Frazee, ca. 1833
Watercolor on ivory
2⁷⁄₁₆ x 2" (6.19 x 5.08 cm)
Gift of Ada Blanche Belknap, 1934.13.1

Daniel F. Smith (dates unknown)
Under the Mistletoe, ca. 1855
Watercolor and gouache over graphite on heavyweight cream wove paper laid on illustration board
23 x 14" (58.42 x 35.56 cm)
Gift of Mr. Wells M. Sawyer (1945), 1984.x.14

William Strickland (1788–1854)
New Theatre, Chestnut Street, 1808
Watercolor and ink on off-white paper
25½ x 33½" (64.77 x 85.09 cm)
Gift of Mr. and Mrs. William Jeanes, 1975.19

Thomas Sully (1783–1872)
Three Classical Figures, ca. 1810
Watercolor on cream wove paper
9 x 6¾" image (22.86 x 17.15 cm)
Gift of Theodor Siegl, 1962.26.2

Unidentified artist
Landscape with Locomotive and Barge, ca. 1840
Watercolor on cream wove paper
5⅝ x 6¹³⁄₁₆" (14.29 x 17.30 cm)
1989.x.4

Unidentified artist
River Scene with Mill, ca. 1822
Watercolor over graphite, India ink border on cream wove paper
15¼ x 21¹⁄₁₆" (38.74 x 53.5 cm)
John S. Phillips Collection, 1983.x.43

Unidentified artist
Solomon Etting, ca. 1810
Watercolor on ivory
2¹¹⁄₁₆ x 2¼" (6.83 x 5.74 cm)
Gift of Frank Marx Etting, 1886.1.8

Watercolor Box, English, ca. 1850–80
Mahogany, Manufactured by Waring and Dimes, London
8¼ x 4⅛ x 2" (20.96 x 10.48 x 5.08 cm)
Charles Bregler's Thomas Eakins Collection

C. Philipp Weber (1849–1921)
Landscape
Watercolor and gouache on off-white wove paper
12 x 13" (30.48 x 33.02 cm)
Gift of Mrs. Jay B. Rudolphy, 1970.7

Benjamin West (1738–1820)
Portrait of Prince Octavius, 1783
Gouache over black chalk on buff laid paper
23⁵⁄₁₆ x 16⅝" (59.21 x 42.23 cm)
Gift of Bernice McIlhenny Wintersteen, 1983.16

T. Worthington Whittredge (1820–1910)
Laurel Blossoms in a Blue Vase, ca. 1890
Watercolor on white paper
15 x 10½" (38.1 x 26.67 cm)
Gift of Mr. and Mrs. Edward Kesler, 1975.20.1

Joseph Wood (ca. 1778–1830)
Samuel Etting, 1819
Watercolor on ivory
2⅜ x 1¹³⁄₁₆" (6.03 x 4.6 cm)
Gift of Sarah Miris Hayes Goodrich, 1919.8

Twentieth Century

Ivan Le Lorraine Albright (1897–1983)
And the Starlight in Her Eyes, ca. 1932
Gouache and watercolor on paper
13¼ x 18" (33.66 x 45.72 cm)
Collection of Jules and Connie Kay

Walter Anderson (1903–1965)
Spice Bush Swallow Tail in Blazing Star, ca. 1950–60
Watercolor and graphite on lightweight cream wove paper
8½ x 10⅞" (21.59 x 27.62 cm)
Gift of the Family of Walter Anderson, 1985.3

Walter Anderson (1903–1965)
Yellow Flowers with Pitcher Plants, ca. 1940–45
Watercolor and graphite on off-white watercolor paper
25 x 19" (63.5 x 48.26 cm)
John S. Phillips Fund, 1985.5

Milton Avery (1885–1965)
Artist at Work
Gouache on paper
30 x 20" (76.2 x 50.8 cm)
Makler Family Collection

Milton Avery (1885–1965)
Seaside Watchers, 1945
Watercolor on paper
22 x 30" (55.88 x 76.2 cm)
Private Collection

Jennifer Bartlett (b. 1941)
In the Garden Drawing #53, 1980
Gouache on paper
19½ x 26" (49.53 x 66.04 cm)
Courtesy of CIGNA Museum and Art Collection

Jennifer Bartlett (b. 1941)
In the Garden Drawing #137, 1980
Gouache on paper
26 x 19¾" (66.04 x 50.165 cm)
Courtesy of CIGNA Museum and Art Collection

Alfred Bendiner (1899–1964)
Hotel Monaco and Grand Canal, 1963
Watercolor, pen and ink on white wove paper
10⁷⁄₁₆ x 18¹⁵⁄₁₆" (26.51 x 48.1 cm)
Gift of Alfred Bendiner, 1973.23.6

Eugene Berman (1899–1972)
Dancer (Romeo and Juliet), 1942
Watercolor on paper
12¼ x 9³⁄₁₆" image (31.12 x 23.34 cm)
Gift of Brooks and Nan McNamara in memory of Tom Neumiller, 1999.3

George Biddle (1885–1973)
Grazing Cattle at Base of Popo, 1928
Watercolor over graphite on cream watercolor paper
18¼ x 13¼" (46.36 x 33.66 cm)
Gift of Mrs. Thomas E. Drake, from the collection of her aunt, Margaretta Hinchman, 1956.5.1

Willie Birch (b. 1942)
A Farewell Feast..., 1988
Gouache on paper with papier-mâché frame
44½ x 56½ x 1¾" (113.03 x 143.51 x 4.45 cm)
Lent by The Harold A. & Ann R. Sorgenti Collection of Contemporary African American Art

Morris Blackburn (1902–1979)
Factory No. 2, 1930
Watercolor and graphite on cream watercolor paper
14⅝ x 10¹³⁄₁₆" (37.15 x 27.46 cm)
Leo Asbell Fund, 1986.10

Morris Blackburn (1902–1979)
Stormy Sky, New Mexico, ca. 1961
Gouache on gray paper
22¼ x 30¼" (56.56 x 76.84 cm)
Courtesy of CIGNA Museum and Art Collection

Oscar Bluemner (1867–1938)
Ascension, 1927
Watercolor, gouache and Chinese white
on wove paper mounted on board
10¼ x 15⁵⁄₁₆" (26.04 x 38.89 cm)
John S. Phillips Fund, 1988.5

Adolphe Borie (1877–1934)
Figure Reading, ca. 1920
Watercolor over graphite on cream wove
paper
11½ x 9" (27.94 x 22.86 cm)
Gift of Peter Borie, 1989.12.16

Charles E. Burchfield (1893–1967)
End of the Day, 1938
Watercolor over graphite and charcoal on
white paper
28 x 48" (71.12 x 121.92 cm)
Joseph E. Temple Fund, 1940.3

Charles E. Burchfield (1893–1967)
Purple Vetch and Buttercups, 1959
Watercolor over charcoal on white wove
paper
39¹³⁄₁₆ x 29¹³⁄₁₆" (101.12 x 75.72 cm)
John Lambert Fund, 1961.1

Alexander Calder (1898–1976)
Will She Make It?, 1969
Gouache on paper
30 x 43½" (76.2 x 110.49 cm)
Private Collection

Arthur B. Carles (1882–1952)
Portrait of Caroline, ca. 1920–25
Watercolor on paper
8⅝ x 6³⁄₁₆" image (21.91 x 15.77 cm)
Collection of Dr. and Mrs. Perry
Ottenberg

Arthur B. Carles (1882–1952)
Portrait of Helen, ca. 1920–25
Watercolor on paper
8¾ x 6¼" (22.23 x 15.88 cm)
Collection of Dr. and Mrs. Perry
Ottenberg

Chen Chi (b. 1912)
Avenue of the Americas, New York,
1954
Watercolor and gouache on Japanese
paper
13⁷⁄₁₆ x 53⅛" (34.13 x 134.94 cm)
John Lambert Fund, 1959.2

John W. Chumley (1928–1984)
Country Road, 1957
Watercolor over graphite on white wove
paper
15⅛ x 29" (38.42 x 73.66 cm)
John Lambert Fund, 1957.1

Andrew Michael Dasburg (1887–1979)
Along the Tracks, 1934
Watercolor on cream wove paper
22¼ x 15¼" (56.52 x 38.74 cm)
Gift of Miss Gertrude Ely, 1950.19

Stuart Davis (1894–1964)
Sand Cove, ca. 1931
Gouache on cream wove paper
15 x 19⅝" (38.1 x 49.85 cm)
Gift of Miss Marie Weeks, 1976.8.1

George Walter Dawson (1870–1938)
The Rose and Lily Walk, ca. 1937
Watercolor and graphite on heavy cream
wove paper
22⅜ x 16⅜" (57.47 x 41.59 cm)
Gift of friends of the artist, 1937.17.2

Charles Demuth (1883–1935)
Box of Tricks, 1919
Gouache and graphite on cardboard
19⅞ x 15⅞" (50.48 x 40.32 cm)
Acquired from the Philadelphia Museum
of Art in partial exchange for the John
S. Phillips Collection of European
Drawings, 1984.8

Charles Demuth (1883–1935)
Gladiolas, ca. 1923–25
Watercolor and graphite on white wove
watercolor paper
18⅛ x 12" (46.04 x 30.48 cm)
Gift of John Frederick Lewis, Jr., 1955.7

Charles Demuth (1883–1935)
Tulips, after 1921
Watercolor and graphite on off-white
paper
11¾ x 18" (29.85 x 45.72 cm)
Academy Purchase, 1958.20.3

Arthur G. Dove (1880–1946)
Untitled, ca. 1941–46
Pigment in wax emulsion on cream
medium-weight paper
3⁷⁄₁₆ x 4¹⁄₁₆" (7.78 x 10.32 cm)
Gift of Mr. and Mrs. William Dove,
1985.55.4

Arthur G. Dove (1880–1946)
Untitled, ca. 1941–46
Watercolor and gouache on cream
medium-weight paper
2⁵⁄₁₆ x 4" (5.87 x 10.16 cm)
Gift of Mr. and Mrs. William Dove,
1985.55.6

Arthur G. Dove (1880–1946)
Untitled, ca. 1941–46
Watercolor and gouache on off-white
medium-weight paper
3 x 4" (7.62 x 10.16 cm)
Gift of Mr. and Mrs. William Dove,
1985.55.7

Arthur G. Dove (1880–1946)
Untitled, ca. 1941–46
Pigment in wax emulsion on cream
medium-weight paper
3 x 4" (7.62 x 10.16 cm)
Gift of Mr. and Mrs. William Dove,
1985.55.10

Arthur G. Dove (1880–1946)
Untitled, ca. 1941–46
Wax emulsion and watercolor on cream
medium-weight paper
3 x 4" (7.62 x 10.16 cm)
Gift of Mr. and Mrs. William Dove,
1985.55.11

Arthur G. Dove (1880–1946)
Untitled, ca. 1941–46
Watercolor and gouache on off-white
medium-weight paper
3 x 4" (7.62 x 10.16 cm)
Gift of Mr. and Mrs. William Dove,
1985.55.13

Arthur G. Dove (1880–1946)
Untitled, ca. 1941–46
Watercolor and gouache on cream
medium-weight paper
3 x 4" (7.62 x 10.16 cm)
Gift of Mr. and Mrs. William Dove,
1985.55.15

Arthur G. Dove (1880–1946)
Untitled, ca. 1941–46
Wax emulsion on cream medium-weight
paper
3 x 4" (7.62 x 10.16 cm)
Gift of Mr. and Mrs. William Dove,
1985.55.26

John E. Dowell, Jr. (b. 1941)
Del Mar, 1990
Watercolor and ink on two sheets of
heavy white wove paper
60⅛ x 11¼" (152.72 x 28.58 cm)
Lent by The Harold A. & Ann R.
Sorgenti Collection of Contemporary
African American Art

John E. Dowell, Jr. (b. 1941)
The Myth of Being, 1990
Watercolor and ink on two sheets of
heavy white wove paper
60 x 11¼" (152.4 x 28.58 cm)
Lent by The Harold A. & Ann R.
Sorgenti Collection of Contemporary
African American Art

Lyonel Feininger (1871–1956)
Houses of Hildesheim, 1950
India ink with watercolor, over charcoal
sketch, on off-white laid paper
20½ x 15½" (52.07 x 39.37 cm)
Collection of Drs. Meyer P. and Vivian
O. Potamkin

Mary Frank (b. 1933)
Untitled #9, 1975
Watercolor and ink on ivory wove paper
20⅜ x 26¹³⁄₁₆" (52.39 x 68.10 cm)
Gift of Jalane & Richard Davidson,
1986.25

David Fredenthal (1914–1958)
Times Squared, 1953
Watercolor on paper
54 x 40" (137.16 x 101.6 cm)
Collection of Jules and Connie Kay

Paul Ludwig Gill (1894–1938)
The Lillian, ca. 1927
Watercolor and graphite on composition
board
15¹⁄₁₆ x 21¹¹⁄₁₆" (38.26 x 55.09 cm)
Gift of Mrs. Thomas E. Drake from the
collection of her aunt, Margaretta
Hinchman, 1955.15.4

Sam Gilliam (b. 1933)
Another Rose, 1999
Acrylic and acrylic media on stitched and
folded polypropylene (watercolor
processes)
11 x 13⅜ x 3⁵⁄₁₆" (27.94 x 33.97 x 8.41 cm)
Lent by the artist

William Glackens (1870–1938)
Flicker, ca. 1920
Watercolor, gouache, ink and graphite on
off-white wove paper
5⅜ x 7⁵⁄₁₆" (13.65 x 18.57 cm)
Gift of the Sansom Foundation, 1995.1.14

Morris Graves (b. 1910)
Brooding, 1953
Tempera over bronze powder paint over
gray wash
19⅞ x 30³⁄₁₆" (25.08 x 76.68 cm)
John Lambert Fund, 1963.1

George Grosz (1893–1959)
New York Types, 1933
Watercolor on paper
15½ x 10½" (39.37 x 26.67 cm)
Courtesy of CIGNA Museum and Art
Collection

Hans Hofmann (1880–1966)
Untitled, 1954
Gouache on paper
11 x 14" (27.94 x 35.56 cm)
Private Collection

Edward Hopper (1882–1967)
House on Dune, South Truro, ca. 1931
Watercolor over graphite on white wove
paper
14 x 20" (35.56 x 50.8 cm)
Collection of Drs. Meyer P. and Vivian O.
Potamkin

Earl Horter (1880–1940)
Toledo, 1924
Gouache on cream watercolor paper
15¼ x 12⅛" (38.74 x 30.8 cm)
Gift of Mrs. Thomas E. Drake, from the
 collection of her aunt, Margaretta
 Hinchman, 1955.15.6

Earl Horter (1880–1940)
Female Nude, 1933
Watercolor and graphite on paper
12¹/₁₆ x 17¹/₁₆" image (30.64 x 43.34 cm)
Collection of Jules and Connie Kay

Humbert L. Howard (1915–1990)
Inner Circle at the Circus, 1974
Gouache, charcoal and oil pastel on white
 wove paper
22 x 29¼" (55.88 x 74.3 cm)
Gift of an anonymous donor, 1974.28.2

Philip Duane Jamison (b. 1925)
Plummer's Lilies, 1958
Watercolor and charcoal on heavy white
 paper
22½ x 30⁵/₁₆" (57.15 x 76.99 cm)
John Lambert Fund, 1959.6

Dong Kingman (1911–2000)
Three Statues, 1954
Watercolor on white wove paper
15⅝ x 22⅝" (39.69 x 57.47 cm)
John Lambert Fund, 1957.6

Franz Kline (1910–1962)
Untitled, ca. 1953
Oil base black ink wash and collage on
 cream paper
13⅞ x 18¾" (35.24 x 47.63 cm)
Gift of Gerrish H. Milliken, Jr., 1975.23

Jacob Lawrence (1917–2000)
Going Home, 1946
Gouache on paper
21½ x 29½" (54.61 x 74.93 cm)
Collection of Jules and Connie Kay

Jacob Lawrence (1917–2000)
Images of Labor, 1980
Gouache on paper
25⁷/₁₆ x 18¼" image (64.61 x 46.36 cm)
Lent by The Harold A. & Ann R.
 Sorgenti Collection of Contemporary
 African American Art

Alfred Leslie (b. 1927)
Coal Pile near the Ohio River, 1983
Watercolor on Arches paper
44 x 59" (111.76 x 149.86 cm)
Pennsylvania Academy purchase with
 funds provided by the Leo Model
 Foundation, 1984.3

David Levine (b. 1926)
Girl on Sofa, 1968
Watercolor and casein over graphite on
 white paper
10¼ x 10½" (26.04 x 26.67 cm)
Collection of Drs. Meyer P. and Vivian
 O. Potamkin

Sven Lukin (b. 1934)
Untitled, 1959
Watercolor and ink on white wove paper
22⅛ x 15" (56.2 x 38.1 cm)
Gift of the Betty Parsons Foundation,
 1985.28

George Luks (1867–1933)
Wooded Landscape with Pond, ca. 1925–31
Watercolor on paper
14¾ x 19¾" (37.47 x 50.17 cm)
Gift of Donald and Will Holden in
 memory of Rie Yarnall, 1980.23

John Marin (1870–1953)
Sun, Sea, Land—Maine, 1921
Watercolor and charcoal on off-white
 wove paper
16½ x 19½" (41.91 x 49.53 cm)
Acquired from the Philadelphia Museum
 of Art (Samuel S. White, 3rd, and Vera
 White Collection) in partial exchange
 for the John S. Phillips Collection of
 European Drawings, 1985.21

John Marin (1870–1953)
Weehawkin, New Jersey, 1910
Watercolor over graphite on off-white
 wove paper
13⅞ x 14⅞" (35.24 x 37.78 cm)
Gift of James P. and Ruth M. Magill,
 1957.15.22

Reginald Marsh (1898–1954)
Trainyard with Tankcars, 1932
Watercolor and graphite on white water-
 color paper
14 x 19¹⁵/₁₆" (35.56 x 50.64 cm)
Bequest of Felicia Meyer Marsh, 1979.8.5

Jan Matulka (1890–1972)
Lighthouse, ca. 1926–30
Watercolor and Conté crayon on off-
 white wove paper
15⅜ x 20¾" (39.05 x 52.71 cm)
Gift of Carl Zigrosser, 1955.13.3

Alfred Henry Maurer (1868–1932)
Portrait of a Girl, ca. 1923
Watercolor and gouache over black chalk
 on off-white wove paper
21½ x 18" (54.61 x 45.72 cm)
Collection of Drs. Meyer P. and Vivian
 O. Potamkin

Henry McCarter (1864–1942)
Yearly Tribute to the King of Tara,
 before 1918
Gouache, graphite and chalk on pulp-
 board
26¹¹/₁₆ x 33¼" (67.79 x 84.46 cm)
Gift of Beauveau Borie, 1944.12

Robert Motherwell (1915–1991)
Untitled (from "Lyric Suite"), 1965
Ink wash on Japanese paper
9 x 11" (22.86 x 27.94 cm)
Gift of the Dedalus Foundation and the
 John Lambert Fund, 1994.6.5.1

Robert Motherwell (1915–1991)
Untitled (from "Lyric Suite"), 1965
Ink wash on Japanese paper
11 x 9" (27.94 x 22.86 cm)
Gift of the Dedalus Foundation and the
 John Lambert Fund, 1994.6.5.2

Robert Motherwell (1915–1991)
Untitled (from "Lyric Suite"), 1965
Ink wash on Japanese paper
9 x 11" (22.86 x 27.94 cm)
Gift of the Dedalus Foundation and the
 John Lambert Fund, 1994.6.5.3

Robert Motherwell (1915–1991)
Untitled (from "Lyric Suite"), 1965
Ink wash on Japanese paper
11 x 9" (27.94 x 22.86 cm)
Gift of the Dedalus Foundation and the
 John Lambert Fund, 1994.6.5.4

Robert Motherwell (1915–1991)
Untitled (from "Lyric Suite"), 1965
Ink wash on Japanese paper
11 x 9" (27.94 x 22.86 cm)
Gift of the Dedalus Foundation and the
 John Lambert Fund, 1994.6.5.6

Robert Motherwell (1915–1991)
Untitled (from "Lyric Suite"), 1965
Ink wash on Japanese paper
11 x 9" (27.94 x 22.86 cm)
Gift of the Dedalus Foundation and the
 John Lambert Fund, 1994.6.5.8

Harry Nadler (1930–1990)
Untitled, 1987
Watercolor and Chinese white with ink
 marker and graphite on architect's
 vellum mounted to gray grid-patterned
 wove paper
11 x 8½" (27.94 x 21.59 cm)
Gift of the artist, 1988.23

Gladys Nilsson (b. 1940)
Pussy and Herbert: Their Second Date, 1969
Watercolor over graphite on heavy white
 wove paper
22⅜ x 15¼" (56.83 x 38.74 cm)
Gift of Marion Stroud Swingle, 1986.16

Violet Oakley (1874–1961)
*Henrietta Cozens, Jessie Willcox Smith, Mary
 Nixon and Edith Emerson*, ca. 1918
10 x 14" (25.4 x 35.56 cm)
Watercolor on off-white wove paper
Gift of the Violet Oakley Memorial
 Foundation

Violet Oakley (1874–1961)
*Study for Triptych Altarpiece "David and
 Goliath"*, ca. 1942
Gouache, ink, graphite and gold paint on
 watercolor sketching board
17¼ x 24" (43.82 x 60.96 cm)
Gift of the Violet Oakley Memorial
 Foundation

Shoji Okutani (b. 1950)
Untitled, 1987
Gouache, watercolor and ink on off-
 white museum board
12¾ x 11⅞" (32.39 x 30.16 cm)
Pennsylvania Academy Purchase Prize
 from the Ninetieth Annual Fellowship
 Exhibition, Picture Trust Fund,
 1987.36

Elizabeth Osborne (b. 1936)
Portrait of Tony Greenwood, 1980
Watercolor on Arches paper
29⅝ x 41½" (75.25 x 105.41 cm)
Collection of Dr. and Mrs. Perry
 Ottenberg

Philip Pearlstein (b. 1924)
Two Female Models, 1975
Monochrome watercolor on Arches
 watercolor paper
29⅞ x 41⅛" (75.88 x 104.46 cm)
Gift of Mr. and Mrs. Al Krakow, 1984.20

Irene Rice Pereira (1907–1971)
Exercise in Space #4, 1960
Gouache on ink on paper
9 x 4¼" (22.86 x 10.8 cm)
Collection of Drs. Meyer P. and Vivian
 O. Potamkin

Irene Rice Pereira (1907–1971)
White Flags, 1956
Gouache and ink on canvas
8⅜ x 5⅛" (21.27 x 13.2 cm)
Collection of Drs. Meyer P. and Vivian
 O. Potamkin

Jody Pinto (b. 1942)
Henri with a Soft Meteor, 1983
Watercolor, gouache, grease crayon and
 graphite on rag paper
70 x 93½" (177.8 x 237.49 cm)
John S. Phillips Fund and exchange,
 Courtesy of Gene Locks, 1985.6

Hobson Pittman (1900–1972)
Study for "Summer Evening", 1936
Watercolor over graphite on off-white
 wove paper
20½ x 34¼" (52.07 x 87 cm)
Bequest of Hobson Pittman, 1972.18.85

Henry C. Pitz (1895–1976)
After the Show, ca. 1956
Watercolor and gouache on cream paper
mounted to heavy chipboard
27½ x 21¾" (69.85 x 55.25 cm)
John Lambert Fund, 1957.10

Odgen Minton Pleissner (1905–1983)
The Artist—Piazza San Marco, 1966
Watercolor and graphite on heavy white
wove paper
29³⁄₁₆ x 22⅞" (74.14 x 58.1 cm)
Gift of the artist, 1968.22

Herbert Pullinger (1878–1961)
*The Mines, Mt. Pleasant Breaker, Scranton,
Pa.*, ca. 1912–19
Watercolor on cream wove paper
18⅝ x 14¹⁵⁄₁₆" (47.31 x 37.94 cm)
Gift of Martin P. Snyder, 1986.30.5

Joseph Raffael (b. 1933)
Water with Fish, 1985
Watercolor on heavy paper
28¾ x 38½" (73.03 x 97.79 cm)
John S. Phillips Fund, 1985.11

Walter Newton Reinsel (1905–1979)
Bouquet of Flowers, ca. 1930
Watercolor over graphite on paper
10⅝ x 7¹⁄₁₆" (26.99 x 17.94 cm)
Bequest of Walter Reinsel, 1980.6

Morgan Russell (1886–1953)
Synchromy, 1912
Watercolor and graphite on paper
5⅛ x 3⅞" (13.02 x 9.84 cm)
Collection of Jules and Connie Kay

John Singer Sargent (1856–1925)
Corfu, 1909
Watercolor over graphite on rough wove
paper
13¾ x 19½" (34.93 x 49.53 cm)
Collection of Drs. Meyer P. and Vivian
O. Potamkin

Raymond Saunders (b. 1934)
Untitled, 1991
Gouache, watercolor, ink, colored pencil,
graphite, metallic paint, acrylic paint,
cellophane tape, wooden sticks, a
paintbrush and a pencil on paper collage
49⅞ x 38⅛" (126.68 x 96.84 cm)
Lent by The Harold A. & Ann R.
Sorgenti Collection of Contemporary
African American Art

William S. Schwartz (1896–1977)
Interior with Child, ca. 1955
Gouache on cream wove paper
22 x 19¾" (55.88 x 50.17 cm)
Gift of Mrs. Thomas E. Drake, from the
collection of her aunt, Margaretta
Hinchman, 1955.15.12

Sonia Sekula (1918–1963)
Watersounds, 1949
Gouache and graphite on cream wove
paper
16⅞ x 13¹³⁄₁₆" (42.86 x 35.08 cm)
Gift of the Betty Parsons Foundation,
1985.49

Ben Shahn (1898–1969)
Governor James Rolph, Jr., of California,
1932–33
Gouache on board
16 x 12" (40.64 x 30.48 cm)
Collection of Jules and Connie Kay

Everett Shinn (1876–1953)
Bowling the Bowler, 1916
Watercolor over black chalk on illustration
board and Masonite
23 x 28⅜" (58.42 x 72.07 cm)
Collection of Drs. Meyer P. and Vivian
O. Potamkin

Marianna Sloan (1875–1954)
Chickens, ca. 1900
Gouache on paperboard
14⅞ x 11⁵⁄₁₆" (37.78 x 28.73 cm)
Gift of William P. Starr, Jr., in memory of
Suzanne A. Starr, 1996.2.1

Marianna Sloan (1875–1954)
Landscape with trees, ca. 1900
Gouache on paperboard
12⅜ x 10⅞" (31.43 x 27.62 cm)
Gift of William P. Starr, Jr., in memory
of Suzanne A. Starr, 1996.2.2

Jessie Willcox Smith (1863–1935)
With Thoughtful Eyes, ca. 1909
Watercolor and gouache over charcoal on
illustration board
21⅞ x 15¹⁵⁄₁₆" (55.56 x 40.48 cm)
Gift of the Estate of Jessie Willcox Smith,
1936.22

Robert Stackhouse (b. 1942)
Deep Swimmers and Mountain Climbers, 1985
Charcoal, graphite, watercolor and
Chinese white on cream wove paper
89½ x 119¹⁵⁄₁₆" (227.33 x 304.64 cm)
John S. Phillips Fund, 1987.9

Joseph Stella (1877–1946)
The Telegraph Pole, 1917
Gouache, pen and black ink on heavy
white wove paper
25⅛ x 19¾" (63.82 x 50.17 cm)
Collection of Drs. Meyer P. and Vivian
O. Potamkin

Vera White (1889–1966)
Morning Glories (Jimson Weed), ca. 1940
Watercolor over graphite on paper
21⁹⁄₁₆ x 14¼" (54.77 x 36.2 cm)
Gift of Milton J. Garfield, 1979.10

William T. Wiley (b. 1937)
For M.W. and the Pure Desire, 1985
Watercolor, graphite, colored pencil, pen
and ink on Arches paper
22 x 30" (55.88 x 76.2 cm)
John S. Phillips Fund, 1989.17

Catherine Morris Wright (1899–1988)
String Quartet, 1936
Watercolor with Chinese white over
graphite on cream wove (laid pattern)
paper
25¹³⁄₁₆ x 20" (65.56 x 50.8 cm)
Gift of Ellen Saltonstall and Robert
Kushner, 1988.25

Andrew Wyeth (b. 1917)
Hauling, 1939
Watercolor on white wove paper
15 x 30½" (38.1 x 77.47 cm)
Gift of John Frederick Lewis, Jr., 1958.24

Andrew Wyeth (b. 1917)
Wet Spring, 1978
Watercolor and gouache on heavy white
wove paper
29 x 22¼" (73.66 x 56.52 cm)
Bequest of Bernice McIlhenny
Wintersteen, 1986.31.1

Marguerite Zorach (1887–1968)
Leisure, ca. 1913
Watercolor and black carbon pencil on
buff wove paper
13⅜ x 17⅜" (33.97 x 44.13 cm)
Collection of Drs. Meyer P. and Vivian
O. Potamkin

Marguerite Zorach (1887–1968)
The Storm, ca. 1913
Watercolor over graphite on off-white
laid paper
12¼ x 15¾" (31.12 x 40.01 cm)
Collection of Drs. Meyer P. and Vivian
O. Potamkin

Zsissly (Malvin Marr Albright)
(1897–1983)
The Trail of Time is Dust, 1962
Watercolor and gouache on paper
27½ x 40½" image (69.85 x 102.87 cm)
Gift of the artist, 1966.12

Photo Credits

All photographs by Rick Echelmeyer